Barbican Art Gallery, London
8 july – 5 september 1993

The Museum of Modern Art, Oxford
16 january – 10 april 1994

Glynn Vivian Art Gallery, Swansea
june – july 1994

The Shigaraki Ceramic Cultural Park, Japan
march – may 1995

theraw and thecooked
new work in clay in Britain

isbn 0 905836 79 0

acknowledgements

Curated by Alison Britton and Martina Margetts
Organised by The Museum of Modern Art, Oxford

 Crafts Council Funded

Published by The Museum of Modern Art, Oxford
©1993 The Museum of Modern Art and the authors

Exhibition designed John Pawson
Catalogue designed by Malcolm Garrett, Assorted Images
Photography by David Cripps
Assisted by Paul Westbrook
Except page 24 by EKWC
and page 25 by Peer van der Kruis

Exhibition co-ordinated by John Leslie
with Jacqueline Yallop, Pamela Ferris and Graham Halstead
Tour co-ordinated by Janet Moore
Exhibition co-ordinated at the Barbican by Carol Brown

Printed in Great Britain by The White Dove Press Ltd
Typeset in Bell Gothic, Lubalin and Spartan Classified

Cover 'Hook Figure' by Gillian Lowndes

The Museum of Modern Art is a Registered Charity
(No.313035) and receives financial assistance from
the Arts Council of Great Britain, Oxford City Council,
Oxfordshire County Council, Visiting Arts and Southern Arts
Recipient of an Arts Council Enhancement Funding Award

This exhibition is the third in a series of surveys of recent visual culture in Britain started by the Museum of Modern Art in Oxford in 1987. The first, Current Affairs, examined a range of painting and sculpture made during the eighties and travelled, under the auspices of the British Council, to Budapest, Prague and Warsaw. The second, Signs of the Times (1990), which also toured, looked at the interface between video art, audio art, slide projection and sculpture during the same period.

This exhibition, The Raw and the Cooked, examines an area of activity, in a single medium – clay – which, although vigorous and prolific, has not previously been exhibited because it straddles the boundaries of craft and sculpture.

The idea for this exhibition originated in discussions with David Kay, Crafts Officer of Southern Arts, who suggested Alison Britton and Martina Margetts as selectors. The Museum of Modern Art receives an annual grant from the Arts Council and is also most grateful to the Crafts Council for the special grant they made to this touring exhibition. The early interest of the Barbican Gallery also was instrumental in making the project viable.

Most importantly we are indebted to the artists and lenders who have made their work available for the exhibition and its tour which will cover both the UK and Japan. Without their help and co-operation the exhibition would not have been possible.

David Elliott
Director
Museum of Modern Art Oxford

contents

'The aim of this book is to show how empirical categories – such as the categories of the raw and the cooked, the fresh and the decayed, the moistened and the burned..., which can only be accurately defined by ethnographic observation and, in each instance, by adopting the standpoint of a particular culture – can nonetheless be used as conceptual tools with which to elaborate abstract ideas and combine them in the form of propositions.'

Claude Lévi-Strauss
The Raw and the Cooked Paris, 1964

foreword David Elliott

Anthropology should begin at home. The opening paragraph, of Lévi-Strauss's seminal book not only qualifies the basis of the Empiricist tradition so dear to British philosophers, but also goes a step further: using a small number of myths collected from disparate, distanced but related communities, the author hopes to demonstrate that "there is a kind of logic in tangible qualities" and by doing so to reveal the laws which govern it.

Logic and myth. These two, abstract, entities span the problem which this exhibition confronts. The idea of craft, of which the field of ceramics is usually deemed to be a part, is based on a number of myths. The most pervasive and historicist of these is that the making of objects by hand is, in some sense, a moral activity; much more so than the making of art (which, some may argue, countenances a multitude of sins). The focus in craft rests on the nexus of creation itself: the uneasy, new, unisex word coined in English – maker – for the presumably superannuated craftsman or craftswoman simply reinforces this. And the objects which result often continue to bask in the secure, but ultimately limiting, afterglow of their origins.

Logically, we may ask, why need this be the case? And it is this question which lies at the heart of the exhibition. Its design and layout, the contents and look of the catalogue, and the mixing of people with craft and art backgrounds with the single qualification that they make sculpture or objects out of clay and, in differing degrees, give emphasis to subject matter, imagery and form – all these challenge conventional categories and expectations.

In spite of its moral baggage, craft, in a post-industrial world, is essentially a normative description of a range of objects which are produced, exhibited, funded, sold and owned within a particular framework. This structure is not completely rigid but practitioners within it tend to have studied and shown their work in the same places. They have been funded by the Crafts Council rather than the Arts Council and within their separate media different and discrete values – both aesthetic and monetary – have been bestowed on their work. Such structures tend to re-inforce themselves in that they promote a market of ideas and attitudes as well as of objects. But a distinction may be made between the superstructure of modern craft and the individual whom it co-opts; at this level possibilities always lie open for exploration and transgression.

Alison Britton and Martina Margetts, the selectors of this exhibition, take these possibilities as a starting point and both point to the roles of William Morris and Bernard Leach in determining the British view of craft in this century. In Leach's response to Japanese culture, it was the integration of art with nature and of hand with object that impressed him. I suspect that the moral values that he attached to this were in some sense a misunderstanding as they were unavoidably Western and there was no direct equivalent for Zen thought in western culture. This in itself is no criticism of Leach as misunderstanding, wherever it may occur, is more often a greater stimulus to creativity than understanding ever could be. But this is a paradox that Oscar Wilde, another admirer of culture from Japan in the closing years of last century, would have been in a better position to articulate. Some of his utterances have the acuity of a Zen ko-an, and in this context his aphorism that 'the fact of a man being a poisoner is nothing against his prose' – illuminates an immutable, if unpalatable, fact about art which the ethical hands and minds of the Leach tradition seem, at times, to have had difficulty in grasping. The importance of truth to materials, authenticity, fitness for purpose and competition within the craft tradition left little room for irony or paradox.

Within the complex cultures of post-modernism, where things are never quite what they seem, the well established duo of irony and paradox have long headed the bill. Reflections on reflections may run the risk of tedium – of becoming infinitely self-regarding. But, within the close atmosphere of British craft ceramics, they have offered to many of the artists shown here a vigorous and serious alternative to the worthiness of good intent.

As any anthropologist will tell you: there are many ways of skinning a cat. The orchestrated collision of works in this exhibition celebrates this truth. Skinning cats is both a craft and an art – as the work you see makes patently and enjoyably clear.

use, beauty, ugliness and irony Alison Britton

In borrowing the title 'The Raw and the Cooked' from anthropology there is an intention to recognise part of what is special about ceramics, and its surprisingly consistent place in our culture. Anthropology has made an immense contribution to the way we think about the world and our own society in this century, on an ordinary level. However this has been absorbed, through the National Geographic Magazine, the Sunday colour supplements, travel, television, looking at objects in museums, or the everyday experience of multi-cultural living, a comparative sense of our own cultural norms as against others that are so different, has had to develop; and this has shifted Waspish parochial certainties. The work of anthropologists has revealed and defined the extent of difference, the subtlety and, perhaps too, the enviable clarity of other social structures. In response Europeans have (at best) found in cultural comparison a broader base of respect for 'otherness' and an expanded, postmodern view of the world.

What I know about other cultures I have taken in as much from looking at objects, in museums or just being abroad, as from reading. 'Reading' an object, its use and its beauty, guessing at its significance or symbolic meaning, how it fits with life, its ingenuity, with material and making, its economy or extravagance, has been a consistent part of art education in my experience. From secondary school onwards, an involvement with ceramics has entailed a dedicated 'looking out', with awe, at the widest possible range of objects from elsewhere. Ethnographic museums are a normal part of the curriculum in ceramics. And on the other hand, pots, or shards, have a significant role to play in historical and anthropological studies of how other peoples have lived. Fired clay doesn't disappear; clay is basic stuff, universal, it is dug up almost everywhere, and almost every culture has a ceramic tradition, except where the earth is frozen. There is a commonality of approach too, techniques have evolved with similarity in different places, or have been carried by emigrant craftsmen, or copied off imported goods. Ceramic objects are by and large internationally comprehensible, with the pot or container as the crux of understanding.

Arguably, we have Bernard Leach to thank for the survival of ceramics as a strand of late twentieth century culture. The practice of pottery as a self-conscious activity, not motivated by the need for utensils but by spiritual and aesthetic hope and expression, was confirmed by him with his concept of the "Studio Potter". It comes, too, under William Morris's umbrella of resistance to dehumanising industrialisation. Leach, on his return from the Far East with Shoji Hamada, set up a pottery in the west of England in 1920, and his subsequent fame and influence as a maker and a craft philosopher defined the territory that we still occupy, despite changes in the appearances of the objects. It is striking that it was a cultural mix – medieval English with Japanese Mingei pottery traditions – that became so durably impressive in style. The Leach school looked with passionate admiration to the Far Eastern potters, not only for the aesthetics of the pots themselves but for what they perceived to be a more wholesome and spiritual approach to making, and to the relationship between man, art and nature. They had arrived early at a sense of European loss, (the degeneration that comes with progress), and of shame at the poverty of their own production. Michael Cardew, the potter who worked for many years in West Africa, wrote of the impact of Leach's view, as if it were a David taking on the Goliath of Wedgwood; and of his own intense antipathy to the dead whiteness of industrial earthenware:

'Rousseau did not actually want to become a Noble Savage; nor Diderot a Chinese, nor Montesquieu a Persian. They invoked those exotic and imaginary characters in order to question Western civilisation; not to destroy it but to fulfil it. ...We do not want to make Chinese, or Korean, or primitive pots. But we have seen clearly what they have which our own so badly lack, and having seen it we are not likely to lose sight of it again.' (From The Maker's Eye catalogue, The Crafts Council, London, 1981.)

Whether or not they realise it, people who choose to work as artists in clay now, are tapping into a twentieth century history of gentle or genteel resistance to some of the larger sweeps of modernisation, standardisation, over-production, mechanisation, sanitisation, mass-marketing, and other aspects of progress that threaten to crush the human spirit. This is our starting point for this exhibition. In anthropological terms the title 'The Raw and the Cooked' alludes to the relationship between Nature and Culture. But here, having acknowledged a particular thread running between anthropology and the practice of ceramics, the title is more precisely a useful metaphor for art's, – any kind of art's – urge to roughen, contrast and enrich the diet of sophisticated, smooth and increasingly passive modern life in the industrialised West. In addition it can be read as a description of ceramic process; and we also perceive the exhibition as a synthesis, as a resolved combination of disparate ingredients, like a meal.

The ingredients of this meal are unusual in that pots and sculpture are not segregated, and neither constitutes the main course. At the outset pots may be what is expected in a ceramic exhibition, the sculptural work is less predictable – the cooked and the raw, perhaps, in terms of familiar visual experience in clay. The work was chosen out of personal interest, the combined vision of the selectors; the exhibition does not attempt to present a complete survey of the current state of ceramic art. The thematic groupings that the work, in a loose fashion, falls into, are ones that became apparent to us after we had roughed out a list of the artists we were committed to. Some work could be seen to belong in several groups, and sometimes the visual links that can be made between particular objects cut across the categories, and these juxtapositions are just as interesting and important to us as any theme. An exhibition like this celebrates the value of mixture, drawing both on the diversity of cultural influences and on the mixing of supposedly 'pure' categories: sculpture/pottery, representation/abstraction, aesthetic/useful, and so on.

The sense in mixing pots and sculpture, beyond their obviously shared use of space and material in this context, can be defined in several ways. The common ground is not just the substance of clay, but the common chemistry and technology that the practitioner has had to grasp with varying degrees of elaboration: ways of forming, glazing, firing – knowing as well as using the stuff. The vast spectrum of mundane to sublime ceramic production that is familiar to us – brick, urinal, teacup, urn, statue, altarpiece – has always seemed to me to be one of the reasons for working in the field. Such a varied traditional range can encourage a feeling of openess, of ambiguity and the hybrid, of intriguingly blurred categories. (The raw, the cooked, and the half-baked, perhaps...) Having one foot planted in utility, in the ordinary, can nourish the aesthetic. Work can come and go between these poles. Use and Beauty for Bernard Leach were supposed to be poised in equal parts; but clearly the balance can be shifted, and the meanings of both words seem now, after the developments of the last twenty years, a great deal more elastic and open to argument. The use-and-beauty

measure can then be applied as purposefully to the art object as to the functional object. For Lévi-Strauss all social behaviour, like cooking and eating, however utilitarian, is always symbolic; in other words it conveys meanings that go beyond its immediate function. In a related sense utilitarian objects carry symbolic – and thus potentially aesthetic – values.

Is there still a problem with looking at a pot as a work of art, or a clay object as a sculpture, and is a plate hanging on the wall an aberration? This exhibition presumes not. There are more interesting dichotomies to consider, like representation and abstraction.

It is noticable, broadly speaking, that the younger artists included in this exhibition are more interested in figurative representation, Philip Eglin, Susan Halls, Tracey Heyes, for instance. The middle-aged group are more clearly the children of Modernism, concerned with formal abstraction, and some with the hollow container form. But to see the exhibition as split in this way is to oversimplify and to diminish the subtlety of the whole range. The range extends to artists who usually work in other materials; or to those who have moved into or out of claywork quite recently. We also particularly wanted to show the work of several ceramic artists with a long-established independent stance: Gillian Lowndes, Paul Astbury, who couldn't be further from thoughts of pottery, however abstract, or Richard Slee, who felt in the early eighties that abstraction was inappropriate to ceramics, and whose current work is an affectionate satire on suburban England and the Toby jug.

That something as concrete as a pot can be regarded as 'abstract' may seem problematic. The sort of pots that are part of this exhibition do not have utility uppermost in their offerings. They are operating like other abstract works of art in that they are aesthetic compositions of three dimensional form (hollow in this case), colours, and surfaces. They make suggestions, references to other sorts of form, other objects, perhaps, or attempt to symbolise states of feeling or ideas. They are carriers of meaning, open to interpretation by the beholder, of a subliminal kind. It could be said, that although as pots they are objects, they also have 'the pot' as their subject matter, in a way that is both ironic and reflexive. It could even be said that although they function as abstracts in the way I have described, they are also representations of pots. They portray ideas about pots in the past, ideas about use, and the relationships between people and everyday objects, the basic props of life. (Eating, drinking, washing, storing, watering, burying.) All of these durable themes are made accessible in the choice of a hollow ceramic form. Containment, actual and metaphorical, is the key to it.

The formal and significant characteristics of pots have been written about at length in other places. To sum up: a form that is overtly hollow and frequently curvaceous, with a related interior and exterior appearance, can very easily seem to be a metaphor for the human body or self. More angular or geometric pots seem to relate to buildings, and perhaps to sleights of scale and to an architectural sense of space. Look at the work of Ken Eastman or Martin Smith. Combining these two references, body and building, the idea of the house as a metaphor for the self can also be perceived in pot forms. More loosely amalgamated, highly fused, and geological-looking pieces readily make suggestions of landscape, pre-history, and forces of nature. I am thinking here of the work of Lawson Oyekan, Ewen Henderson, and Sara Radstone.

We hope to show in this exhibition that work in clay is an open arena, and that people are making things currently in unforseeably exciting and varied forms;

1

(there is a certain risk and pleasure in bringing them all into the same space.) Within this diversity some ceramic norms are challenged and others are confirmed.

One of the conventions of ceramics is that the clay is covered with a surface layer, usually of vitreous slip or glaze. This is to make it impervious. Certain clay objects, like bricks and flower pots, are meant to be porous, but in general, unglazed looks unfinished. High temperature firing of clay also vitrifies it, makes it glass-like, but the glazing convention is so ancient that it has also become an avenue for decoration, or painting. Decoration, as 'applied' to pottery, was supposed to be subservient to the form. (Often, in industrial job-division, applied by women onto shapes made by men.) Ceramic artists can choose to paint the surface of their objects now for different reasons and in different ways, but it has developed out of this practical requirement, the need for a waterproof skin, as well as the added value of ornament and colour. The separate concern for surface is something special to ceramic art, which in this way brings together sculpture and painting, as body and dress. In the way I make pots I have worked out a process where the painting and the form can develop in dialogue at the same time, without one dominating the other.

Plates and painting have a particular relationship too. The flatness of plates, their lower 3-D formal status, makes them potentially closer to paintings. They are objects in transition, poised between object and image. This is wryly commented on by Philip Eglin, combining a Manet painting and a willow pattern border. Karen Densham, too, has a gentle humour in her faint, careful horse drawings under bold splashes of glaze. The titles are potent and poetic, a racehorse's name with an optional innuendo.

Stephenie Bergman's grand series of forty plates is not at all concerned with painting and not much with 'ceramic quality'. Like a large number of pieces in this exhibition her work is unglazed. This in itself works to confront ceramic norms. The Bergman piece is a structural surface in relief, raw and direct, a huge geometric drawing in pieces on a wall, playing with light and shadow. It is another manifestation of the irony that ceramics thrives on, glancing at function, picking up on our familiar acceptance of a basic form, and subversively aesthetic.

These subversive strands are pleasing and important to include because they suggest change and vitality. The untasteful ambiguity of Richard Slee's oversized plants and Toby jugs, glossy and sleek. The wanton dribblings of pigment over the features of Philip Eglin's ladies. Any field that is founded on a single material and a few thousand years of craft technology is bound to have a certain orthodoxy that needs disruption as well as respect. This exhibition will, I hope, convey both upheaval and poise in its celebration of the long traditions of making objects in clay.

metamorphosis: the culture of ceramics
Martina Margetts

All kinds of battles, not just military ones, are fought in the name of civilization. A few have affected the course of culture in contemporary Britain, and with this the current position of ceramics. The battle of the sexes, waged by women to achieve equality with men, has enfranchised the creative achievements of women and the hand processes associated with the crafts and domestic contexts. The current exploration of gender (transexuality and androgyny) in terms of personal and cultural identity, has further liberated conventions of thought. The battle of high versus low (popular) culture has reached a stand-off between the Madonna/Mozart, Dylan/Keats camps, since never again can culture be narrowly defined within Matthew Arnold's nineteenth-century, socially-improving model. Cultural relativism (the postmodern absence of hierarchy and absolute standards) and multiracialism now rule.

Ceramic art is thriving in this homogenous, relativist climate, aided especially by developments in sculpture and design. Both are engaged in a more variegated, tactile, metaphorical approach. Sculptors aim not to represent the world, but to explore its meaning through materials, processes and the nature and function of objects in a metaphysical way. Designers recognise the significance of emotion in the buying of consumer goods: the need for a light, a kettle, a chair to offer, both functionally and stylistically, a more specialised relationship with its owner. For example, products by the Memphis Group, Alessi, Ron Arad, Philippe Starck, Stefan Lindfors and the lighting designer, Ingo Maurer, all typify this experience.

Ironically, it is the postwar history of ceramics itself, as much as the absence of a sympathetic cultural context, which has delayed the present coming of age of British ceramic art. Despite some experimental post-war ceramics, the twin peaks of Bernard Leach (1889-

1979) and Hans Coper (1920-1981) have loomed so large that it seems only now, at the end of the century, that ceramics here can be freely made and assessed across the whole spectrum of structures and purposes. Elsewhere, this tunnel vision has been less evident, especially in the United States and Japan. For example, Peter Voulkos, instigator in the 1950s of Abstract Expressionism in American ceramics, and the revolutionary ceramic artists of the Sodeisha Group (founded in Japan in 1948 by Kazuo Yagi and Osamu Suzuki) created in their work an exciting relationship between form and surface skin. Their works, apparently chaotic in structure, offered, on the contrary, a new sense of order in ceramics, akin to that achieved by Picasso in the fine arts. Newness of feeling led to newness of form.

By contrast, in Britain in the 1950s and 1960s, pots remained within conventional parameters, from William Staite Murray to Sam Haile, while non-vessel ceramics seemed cut off from the artery of mainstream sculpture. Ideas, scale, form and especially the clay material (a provisional basis for, say, bronze sculpture, rather than significant in its own right) were delimiting factors.

Leach's holistic vision, too, of life and work together producing beauty, harmony and a sense of useful purpose, was so compelling that the aesthetic he evolved in ceramics prevailed as a badge of allegiance, a symbol of belief. The whole realm of the brown and green betokened these values, becoming a political and social as much as a cultural statement.

The aesthetic charge derived from 'conviction ceramics' manifested itself also, but differently, in the work of Hans Coper, the German engineer-turned-potter who lived and worked in England from 1938 until his death in 1981. The creative strictures he imposed upon

himself, his refinement of form which forced him to work, as he wrote, 'like a demented piano-tuner trying to approximate a phantom pitch', led to a goal of continuous production and to the evolution of a family of vessel shapes through a meditative, reductive process rather than one which relied on catalytic radicalism, as in the US and Japan. Eloquence triumphed over eclecticism.

It is not surprising that the 1970s generation of British ceramic vessel makers exploded that territory with a more experimental approach to form and narrative, which Alison Britton explained in her much quoted essay in 1982 (The Maker's Eye catalogue). Most importantly, she connected her concerns in ceramics to Modernism and to other art forms, especially literature and painting, analysing them within and on those terms. During the 1980s ceramics has, like architecture, moved between Modernism and Postmodernism, between an abstract narrative about form (essence) to a literal narrative about content (synthesis). But the explorations mainly evolved round the form of the vessel, with non-vessel ceramic sculpture confined to its black hole. Although cultural support and stimulus existed, in terms of ceramic development in other countries and a large range of ceramic works made by fine artists throughout the century, the critical and institutional biases seemed to work against this area of ceramics flourishing in Britain.

The separate existence of the Crafts Coucil from the Arts Council, of separate crafts organisations, galleries and departments in museums and art schools, conferred separate intentions on the works, emphasising difference rather than common ground. Added to this was the constricting view of some influential critics and of the public, who conceded that art may present the shock of the new, but who viewed ceramics as an area of conservatism. They preferred to define ceramics in terms of Leachian studio pottery and to link it to the sentiments expressed in, say, Keats' Ode to a Grecian Urn (the pot as 'the still unravished bride of quietness... she cannot fade... beauty is truth, truth beauty') rather than to the ravished, faded image of the Bride Stripped Bare in Duchamp's The Large Glass.

The writings on ceramics by the late Peter Fuller, and those of Peter Dormer, a critic of wider sympathies but who nonetheless is in favour of 'familiar forms' offering 'solace', relate back to the social context and yardsticks of use and beauty promoted by Morris, Lethaby, and Japanese culture. This is acceptable, of course, as one view of current ceramic practice, but only when it is tempered by a knowledge and tolerance of the alternatives. The danger lies in the public's delight in selectively seeing its own traditionalist biases condoned: consequently, the broader reaches of the ceramic avant-garde are ignored.

The role of ceramics in the 1990s is open to much wider interpretation and connection, especially because the climate of painting and sculpture has been propitious and complementary to it. Since the 1960s, sculpture has broken boundaries of material, and form, as evidenced in the exhibition Gravity and Grace of sculpture from 1965-1975, shown recently at the Hayward Gallery: 'The fervent search for other ways of seeing', writes the curator Jon Thompson, 'involved different procedures and methods for making, finding, reflecting, matching, pairing, completing, growing, placing, spacing, and associating. Boundaries grew blurred in a world that seemed to promise a permanent state of change and flux'.

The moral hegemony of Modernism's purist and idealistic fitness-for-purpose ethic, implying an

attainable truthfulness, was also outfaced by Pop, performance art, advertising and a manipulative technological revolution. Objects lost their apparent definitiveness (certainly no sculptural figures on plinths) and creative works became touchstones of experience, rather than finite representations and explanations. From the 1980s, process as product in new British sculpture gave it a hauntingly ambiguous aesthetic and an exciting atmosphere of philosophical enquiry. The sculptures of Richard Deacon, Bill Woodrow, Alison Wilding, Tony Cragg, Antony Gormley, Shirazeh Houshiary and Anish Kapoor have a close affinity with figurative and vessel forms, presenting objects as metaphors, marked and metamorphosed by process.

The choices of materials and techniques, fusing exposed elements with covert messages, has poetically reconnected art to nature, inviting a metaphysical rather than a literal response. In this exhibition, this approach is evident in work by, for example, Antony Gormley, Ewen Henderson, Trupti Patel and Sara Radstone. Their humanistic preoccupation with origins is underscored by their concepts of the natural world. In nature, forms and processes suggest a diagram of forces at work (the four elements, the four seasons, night and day), which need to be harmonised to offer some sense of order and continuity. The psychoanalyst, Carl Jung, recognised that human experience and its conditional process of birth, life and death also demands the reconciliation of opposites. Human aspirations and nature can be related to alchemy, to the notion of transforming nature's prosaic elements and our prosaic selves into a condition of harmony and fulfilment: in this respect, the choice by these artists to use clay is especially appropriate, since it, too, involves the transformation of raw earth through fire into special things of permanence.

The strength of ceramics has always lain in its universality – in terms of geography, form, content and language – a non-verbal, worldwide evocation of spiritual, ceremonial, sculptural and utilitarian functions. The unique versatility of the material, which is able to interpret a great range of styles and ideas whilst retaining its own intimate identity, imbues ceramic works with a particular resonance through time. The sculptor, Eduardo Paolozzi, has emphasised the mix of meaning and memory within the clay material (nature's collective subconscious): 'Shaping a piece of clay is like reading William Butler Yeats poems to the Michelangelo painting of Leda and the Swan – rich in metaphors, intoxicating in its associations and yet mysterious' (The State of Clay catalogue 1978).

The coming of age of ceramic art in Britain, when now the conceptual range of ceramics can be more sympathetically viewed and when the works themselves have become more richly inventive, is the subject of this exhibition. Here clay is not a craft material but an authentic medium for sculpture. The works take myriad forms, in concept, scale and meaning: the continuing exploration of the vessel form, fusing the languages of painting, sculpture and architecture in a physical language of its own, is balanced by works concerned with the ironical re-presentation of ceramic traditions; with figuration; with landscape (physical, mythological, metaphorical); and with identity. This latter realm perhaps most potently evokes current concerns in the context of an increasingly synthetic world, a determination to explain to ourselves what we are about as well as how to survive with some sense of values and civilization intact.

"Clay has a very responsive nature. It marks at the slightest touch in its plastic state illustrating not only marks made purposely but unintentional striations as well. This immediate intimacy naturally demands ambitious use and a somewhat compelling and dangerous seduction is one of many natural responces to take place.

Clay is an intimidating material. The more I use it, the more stringent it forces me to become with the justification of its use. Sculpture demands a very rigorous language.

When I say a piece of my work is finished it is always an estimation. Time physically engages it in a mutual dance, with fate as its partner.

At a high enough temperature, fired clay images remain fixed for eternity even though they may be smashed. Museums are the containers for displaying the shards which like atoms are again fastened together to reform images recognisable to us. for me these two examples are important transitions for clay. Firstly, giving plastic clay a structure and then rebuilding these structures from hardened debris. A curious resurrection, not without the creation of new values.

Clay has no inherent structure. It has to be given. I bring structure to clay using the disciplines of other materials and readymades. Clay represents the ground, the source of provision and elimination.

The sculpture 'Tree in a Landscape' discusses these issues of nature, providing an image which not only carries the message of Life, Death and Resurrection but equally suggests the importance, I hope, of space as a constant principle and provision for changing values."

Paul Astbury

Raincoat
1992
152 x 152 x 8 cm

16

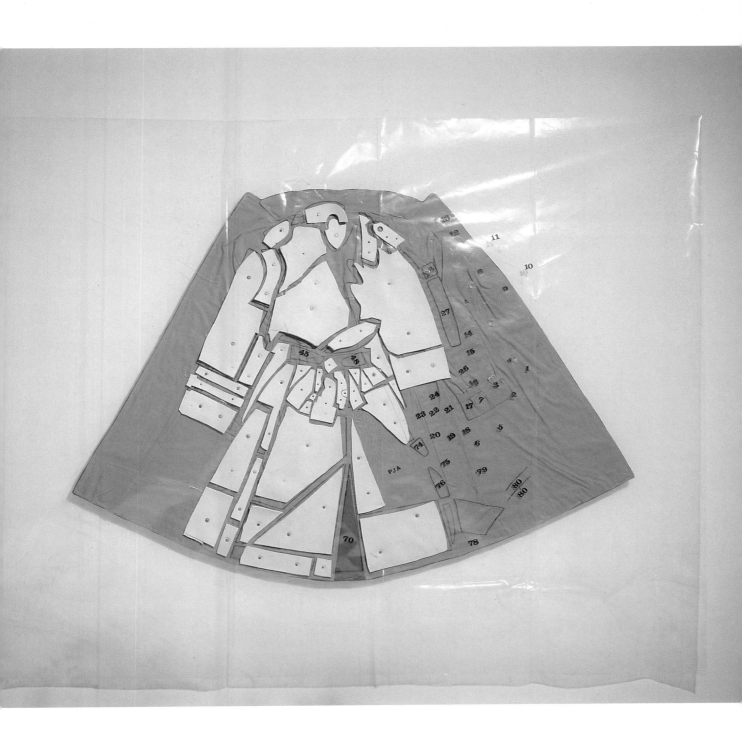

The precise way in which painting and form cohabit in these works, or perhaps drawing and sculpture describes it better, is characteristic of Baldwin's vessels.

In the current work the way he paints the forms is both emphatic and tentative, there is a delicate balance. Geometry is usually the source of it, parallel lines, crosses, arcs and circles. Strong crisply painted shapes seem almost to have been applied whole, while some fine inlaid black lines have an exploratory look, as of they are plotting out where a drawing might go. The confined shapes of the apertures are by contrast often ragged and abrupt. These deep inky splots add intensity to the drawing, besides establishing the fact of the hollow secretive form, dark and glassy within.

Extract from <u>Contemporary Applied Arts</u> leaflet, by Alison Britton, March 1993

Gordon Baldwin

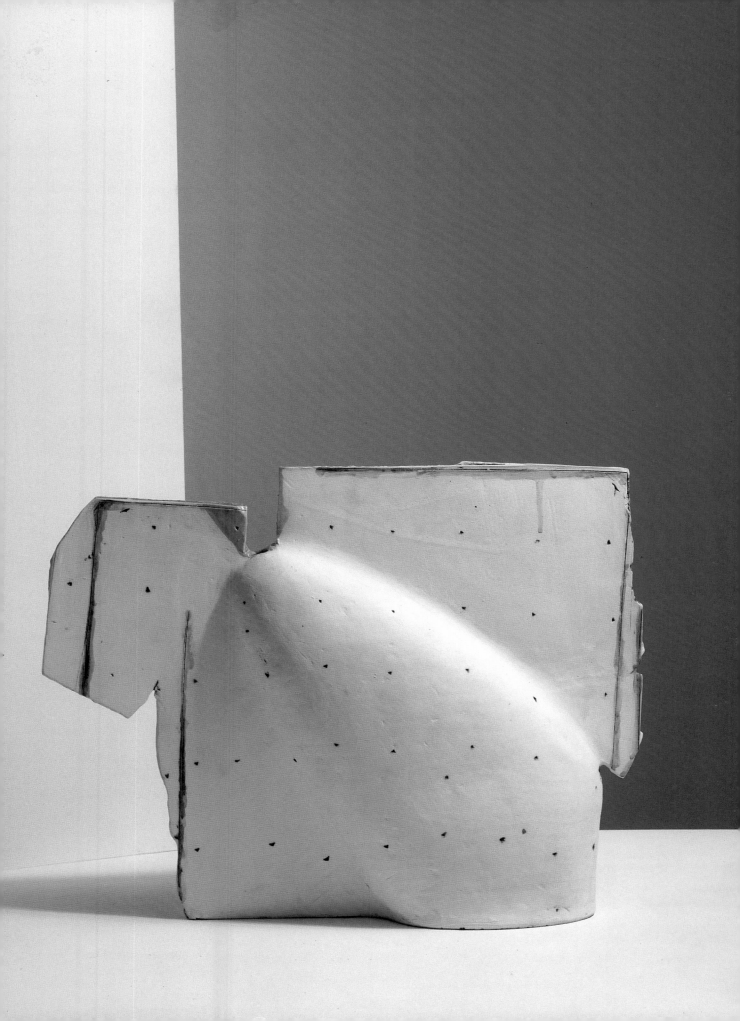

"The reason for making the plates was to find a way to stop making vases — and to find something that would require a longer period of working. It was getting back to using the wall. I gave myself three shapes, square, round and five-sided, and just let it develop. I started by thinking about the surface — structurally associated or similar to things seen — a structural rhythm. Then I realised I could use the making as a way of drawing. The drawing was decoration/formal division of the whole/whimsy. Then sometimes I wanted to describe the edge of a plate — the last thing I thought of was the function.

40 was an arbitrary number. I didn't glaze them as they were thought of as one body of work to go on the wall, and the shininess of the glaze distracts from the surface. However; I wouldn't object to — for example — making a group of six to be used and glazing them."

From notes about the work by Stephenie Bergman.

Stephenie Bergman

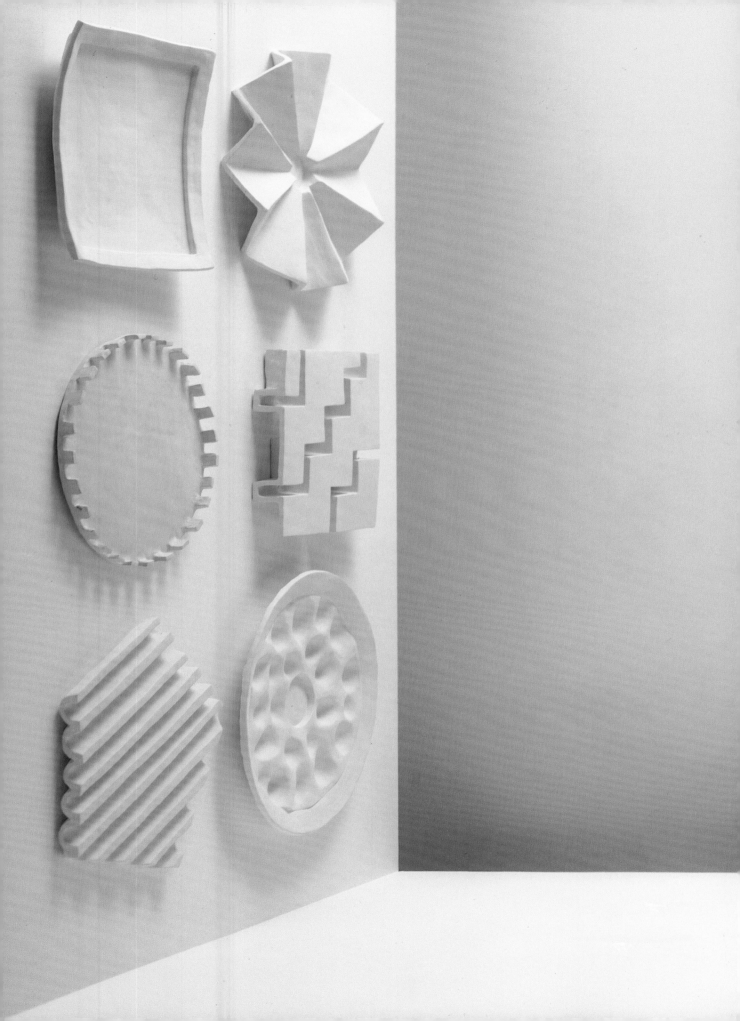

...we can safely observe that the culture does not quite know where to put this kind of work. Sometimes it is consumed as pure ornament. Thus dark pieces may be less popular than for example, blue and white (a combination that has happy associations for the lover of ceramics). There is an element of democratisation — sculpture for the home. Most of us recognise in Alison Britton's work a family of shapes — an echo of collar construction in metal or cloth, a hint of tubing, lots of bowls and jugs. Another audience, lovers of abstraction, formalists, will be drawn to her mark making. In that sense she belongs to the St Ives of painting while being distant from the St Ives of pottery.

Extract from <u>Contemporary Applied Arts</u> leaflet, by Tanya Harrod, March 1990

Alison Britton

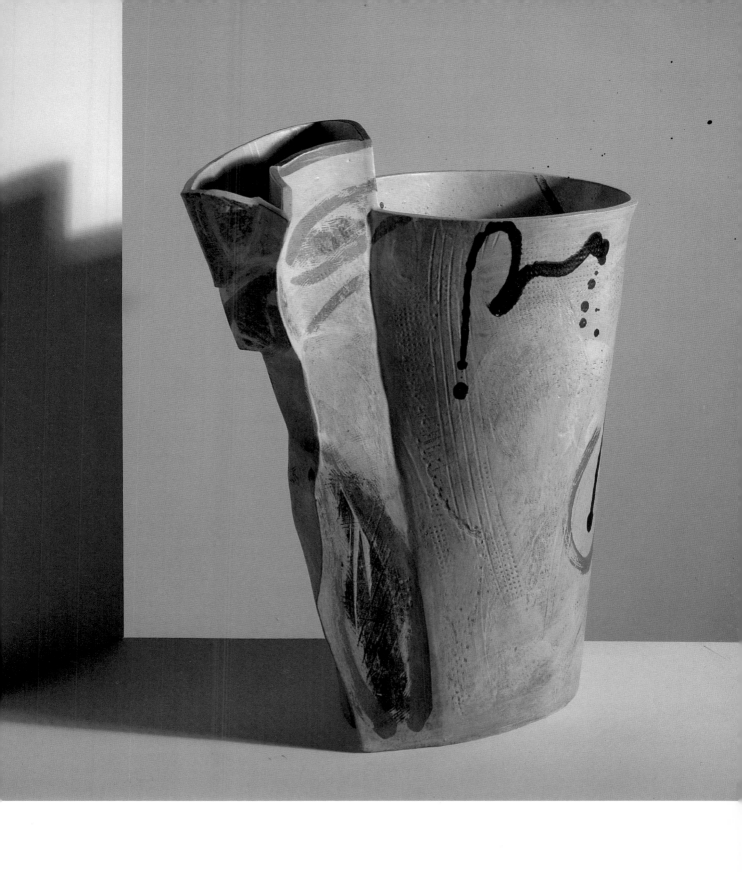

Up to the last century there was only a small group of materials with which one could make sculpture and these were all natural materials. But now, after a hundred years of nomination we can use almost anything to make sculpture with, any material can be used as the carrier of important information. This is the case not just for materials but also for techniques — one can walk art, spit art, love art — and also for formal possibilities. We have had many new media like video, happenings and installations. We have had red rooms, black rooms, earthy rooms, watery rooms and rooms full of horses. As formal possibilities many things have been named. Also, in terms of the content and the issues about which one can make art there have been many important additions. The problem is that in a finite world there are only so many possibilities and at the moment it seems to me somewhat irrelevant to discover a new material to make art with.

My concerns and interests lie in the objects and materials that we produce, that mankind has produced, apart from the natural world, to try and find out something about our relationship with these materials and objects. The reason for doing that is simply because in our language and our thoughts about natural things like wood, stone or fire, we have around these things a sort of balloon of information and associations. Natural things always have very substantial balloons of information around them. The thing has its physical qualities but the balloon around contains its metaphysical qualities, the aspects we bring to that object, its history, its mythology, meaning and aesthetic. We have grown up for millions of years in the presence of the natural world around us and have had time to evolve a relationship with the objects in it. Because of the way and speed in which we have produced new materials and objects we do not have the time to develop a meaningful relationship with these materials. Trying to give these things more meaning, mythology and poetry is the clear predicate of art in this century.

Extract from a talk at the European Ceramics Work Centre Den Bosch, The Netherlands, 17 December 1992

Tony Cragg

Laib
1990
67 x 50 x 53 cm

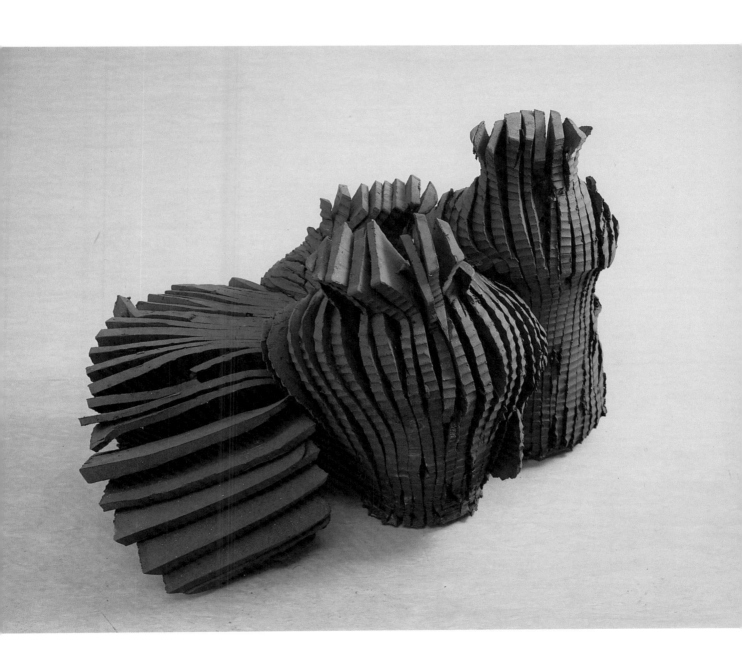

Jill Crowley

In the writing of Samuel Beckett, there is a poignant balance between gaiety and gloom in his characters, wry mirth and irony in the face of desperation and decay; the wit and beauty of the language is juxtaposed with the ludicrous bleakness of the predicament. For me the depth of the appeal that Jill Crowley's work summons, belongs somehow in the same territory. I respond to her imagery in the light of those books. Whether she is making mermaids, cats heads on plinths, vegetables, teapots, hands, feet, goldfish bowls, flattened ladies for the wall, or busts of old men; in the way clay has been formed there is a mixture of the tender and the grotesque that evokes the Beckett tone. She avoids the sentimental entirely, and moves towards the humorous, but to say that these things are comic would be a superficial mistake.

Extract from <u>Contemporary Applied Arts</u> leaflet,
by Alison Britton, April 1992

Pink Hand
1993
34 x 36 cm

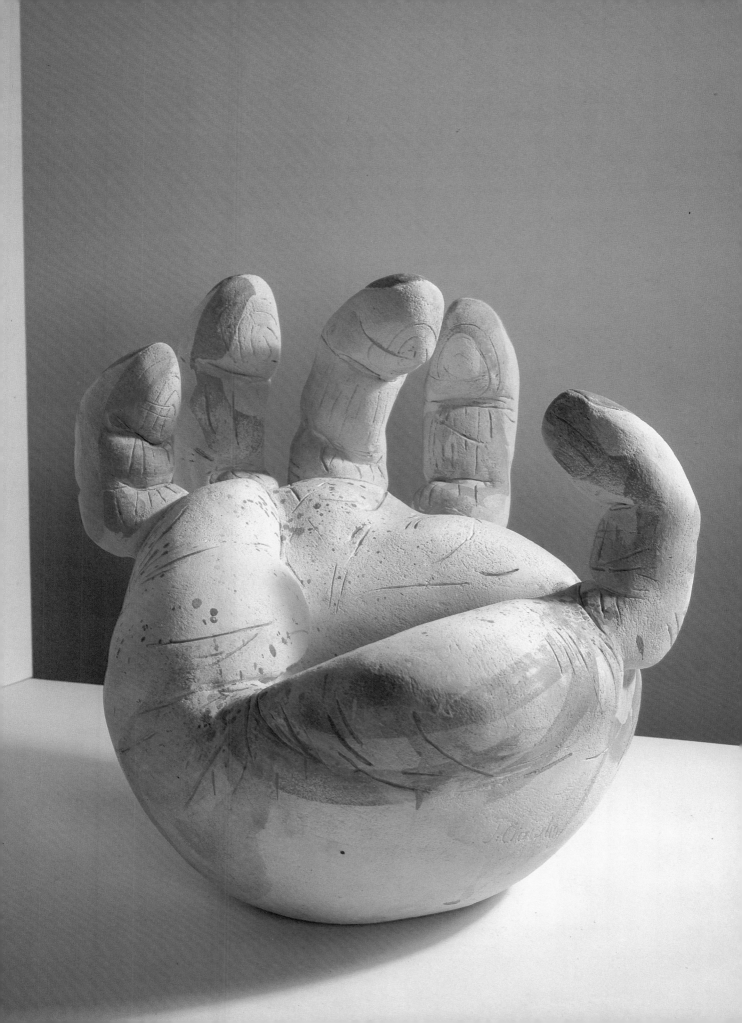

Each series of plates... uses an image taken from a museum catalogue or a pottery textbook. So, the same horse taken from a Staffordshire pottery design appears through a series called "Racing Certainties". The colouring and the ground of each plate are, however, different. Each plate also has a name; just as each horse has its name over the stable-door, each plate has its name incised at the top. It is an echo of the decorative plate tradition, but the titles are also intended to suggest ironic reference to aspects of being a contemporary potter. Hence the link with contemporary art — this is pottery which, though decorative in its own right, is also making the business of being a studio potter part of its subject matter.

Extract from a review in <u>Crafts</u> no 122, by Peter Dormer, May 1993

Karen Densham

Model of a Horse
1992
48 cm

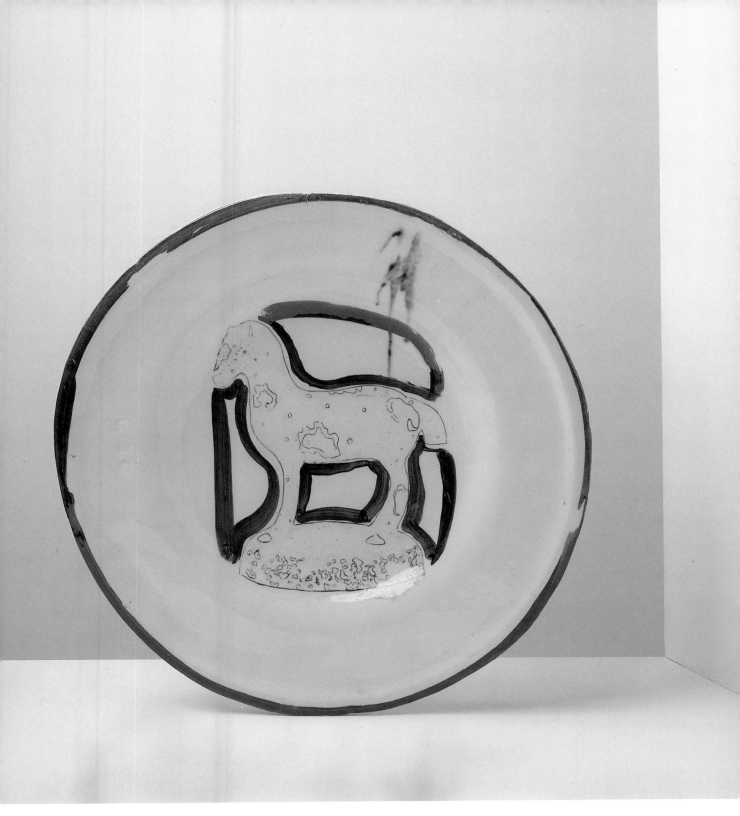

"Shoes: Primo Levi
 V&A costumes
 Figure: Venetian 18th century genre paintings (Longhi and Guardi in Venice)
 Veronese's Supper at the house of Levi in the Accademia
 Picasso's painting of his son
 Musée Jacquemart-André in Paris: Meissen Figurines"

Blue Shoe
1992
approx life size

Ruth Dupré

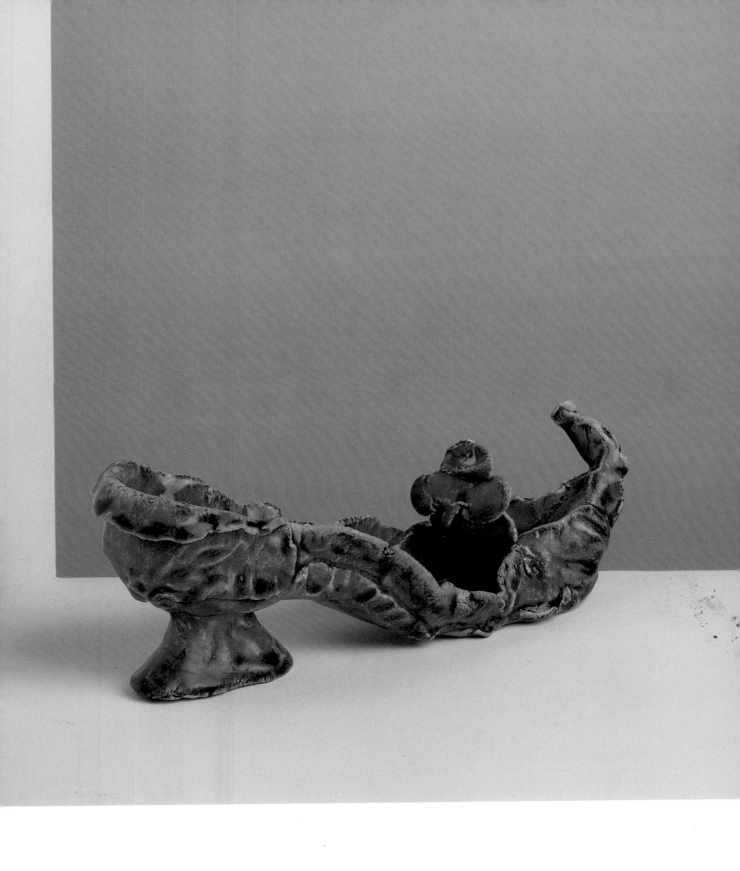

Perhaps a pot can never be as abstract as a piece of sculpture, because being a pot is some kind of a subject reference, but Ken Eastman's tendency is to an abstract extreme within pottery. "I was always keen that the pots were about nothing". Bugged by modernism and an interest in architecture, earlier pieces of his were thought to be reminiscent of buildings, but it was more his intention to compare volumes and to imply a larger than actual space.

Music, the most abstract of all art forms, has the capacity to be about itself, and to cut out a sense of subject, that he appreciates. The person who is playing becomes subservient to the music. Eastman is at the mercy of the song.

Alison Britton, in part quoting from <u>Contemporary Applied Arts</u> leaflet, October 1990

Pot

1993
25 cm

Ken Eastman

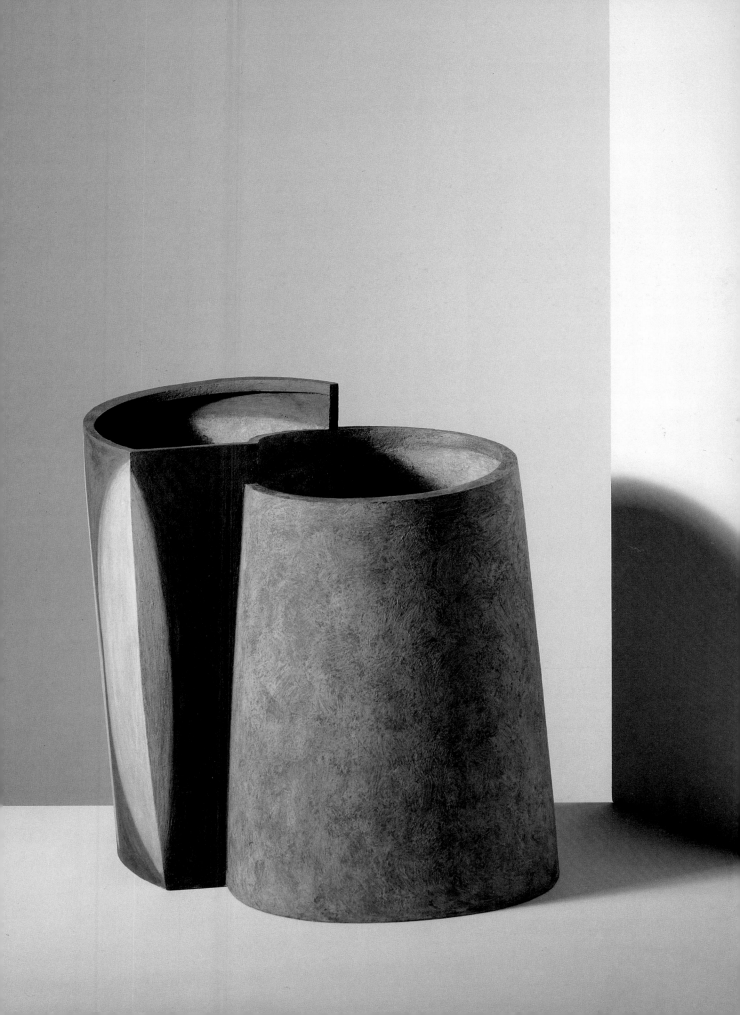

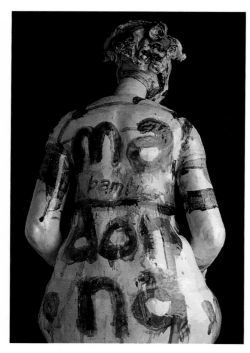

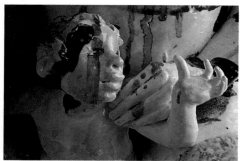

...a Sèvres porcelain Classical figure from the 18th century is entirely expressive of the beliefs, tastes, aspirations and narrative interests of its consumers and makers. In just such a way a Philip Eglin earthenware figure speaks of its time. It is constructed with great bravado and a knowledgable looseness. The joints of the limbs say more about clay than flesh. The poses and the demeanour of the women are full of historical reverence, and yet he has painted all over them. Not just painted, he has slapped and sloshed fierce coloured metal oxide pigments over their bodies in great strokes and dribbles and scrawls of words. Why is this necessary, why has he messed them up? Unpainted they would seem like attempts at reproduction, too daunted by the past. As they are they link the characteristic palette of ceramics, traditions of Staffordshire popular figures, with homage to Cranach and the aggressive deconstructive dash of a modern urban upbringing. They combine the comfort of the familiar with the sense of not going backwards.

Extract from Alison Britton article in <u>Beyond the Dovetail</u> catalogue, Crafts Council 1991

Philip Eglin

Madonna col Bambino

1991
100 cm

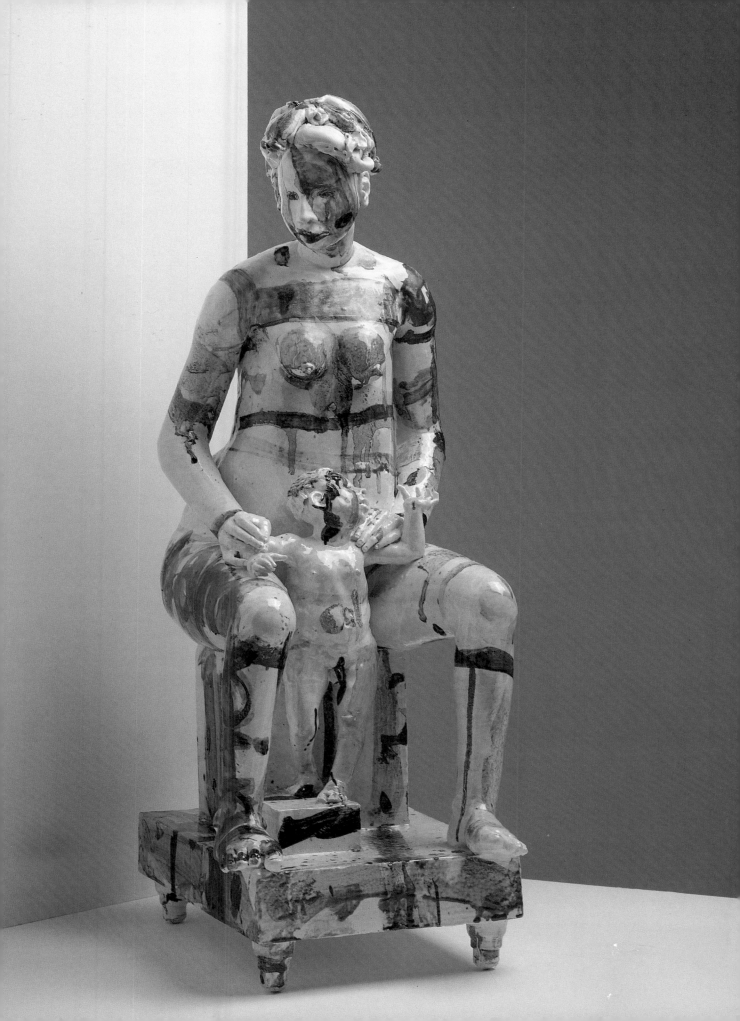

Pots about Equilibrium

(four illustrated from a group of nine)

1992
from 24 x 48.5 cm

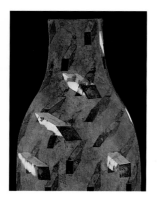

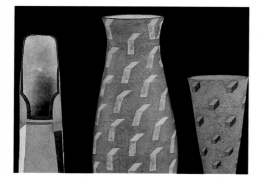

Note on Pots about Equilibrium.

"There is an emphasis on equilibrium in the form between the opposing forces of left and right, front and back, inside and outside, 2 and 3 dimensions, weightiness and lightness, etc., producing in a normal vase or vessel a mood of abnormal suspense and elation.

When it comes to the painted surface, the use of colour and rhythm figures to emphasize the form (as in music) involves balancing opposing forces of a more paradoxical, and almost metaphysical, nature: various fragmentations, and counterpoint such as between light and dark, sharp and soft, upper and lower layers, rhythmic clusterings, etc. This whole 2 and 3 dimensional interplay in curved space might seem impossibly busy and chaotic, but when married faithfully to a given form, can be peaceful, even timeless."

Elizabeth Fritsch

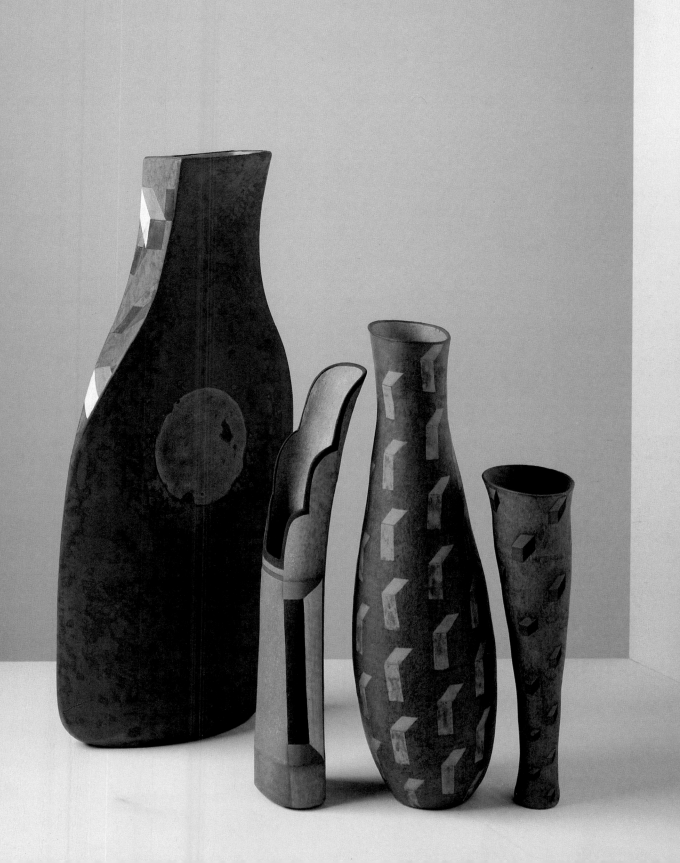

Being the world

"Nature is within us. We are sick when we do not feel it. The sickness of feeling separate from the
world is what is killing it. We are earth above ground, clothed by space, seen by light. The distance
inherent in sight has made us treat the "outside" as different. The dominance of reason depends
on the continued externalisation of the world. The light of reason is balanced by the darkness
of the body. The unknowness of the mind and the unknowness of the universe are the same.
If we are to survive, we must balance outer action with an inner experience of matter.
This is the great subjectivity and the great unity. This unity is expressed by those
who live close to the earth in living ways. We must integrate our perceptions of
the dynamic interpretation of the elements with the workings of the body. We
must become conciously unconcious and unconciously concious. We are
the world, we are the poisoners of the world, we are the conciousness of
the world."

Antony Gormley

Twenty-Four Hours

1988

9 m (2-30 cm high)

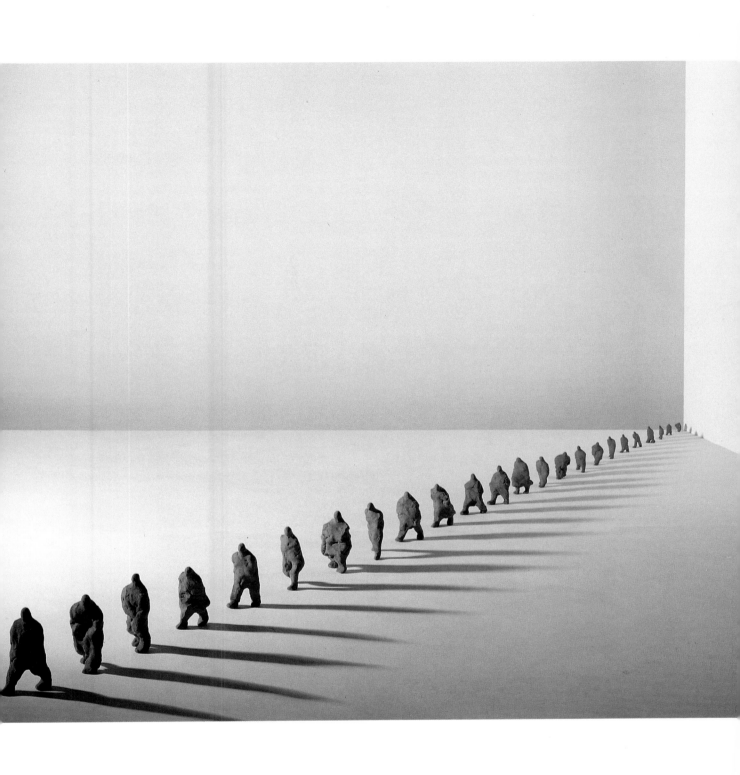

"I cannot remember ever lacking a sense of emotional connection with the natural world. To me, it seems right, and presents the most interesting, honest creative front. Nothing can excite me like an animal can. Dead or alive, the response may be different, but still as powerful. My work is not political, unless it can be said that my sense of seeing is a political act, when expressed in any medium. I disapprove of any animal suffering, but my work is not driven by this. What my work says by this, if anything at all, is for the viewer to judge.

I don't have one way of working. Each piece demands something different... I am constantly trying to forget what I already know."

Susan Halls

Monkeys and Apes
(11 illustrated from a group of 20)
1992
10 cm each

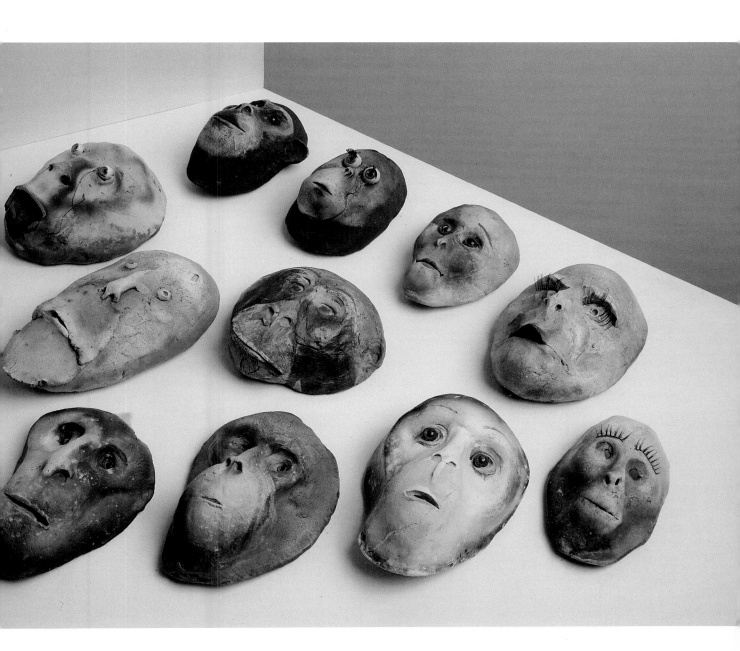

"Robert Hughes in his essay on Morandi in Nothing if Not Critical, wrote: 'Modestly, insistently, Morandi's images try to slow the eye, asking it to give up its inattention, its restless scanning, and give full weight to something small. When Japanese aesthetes spoke of the quality called Wabi, they had in mind something like this: the clarity of the ordinary substance seen for itself, in its true quality... Morandi's entire life was predicated on the prolonged search for it.'

Morandi is an obvious inspiration; Lucie Rie, Hans Coper too. Piero della Francesca, Juan Gris, Ben Nicholson. But more than these, the mystery itself; the Kindness of the stillness beneath the skin. Luckily, beauty can't be understood — only hoped for and sometimes felt. Brancusi's Birds in Space, a Korean penny rice bowl; even, perhaps (I fervently believe) a beaker."

Still Life

1992
25 cm

Gwyn Hanssen Pigott

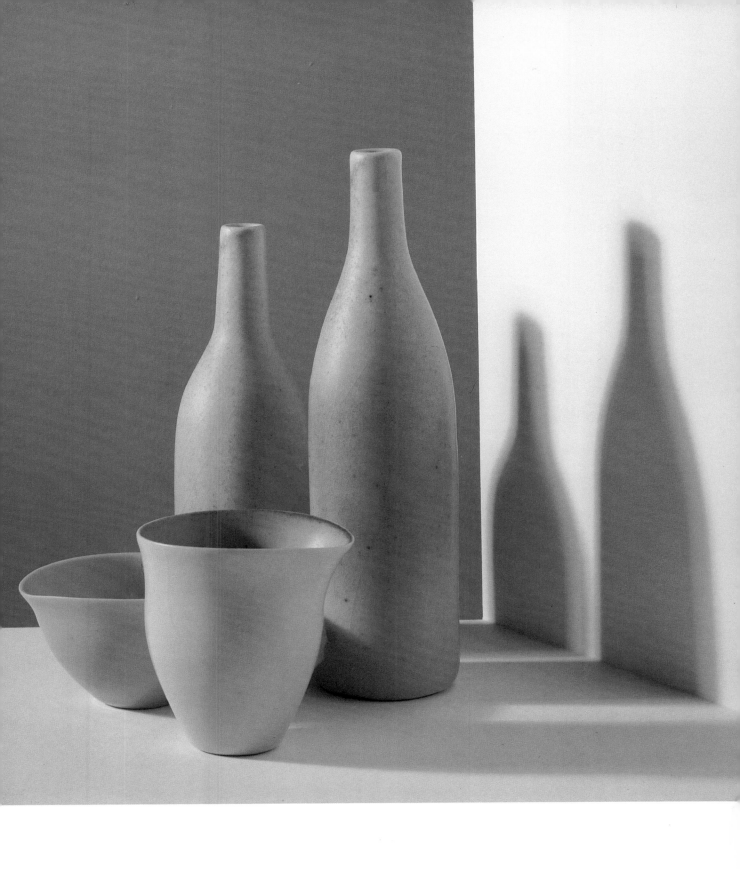

"My present work is obsessed with edges, points of change, endings. It explores the significance of what is broken, torn or cut, the ability of single or multiple forms to speak of either compression or expansion, flatness or fullness. It is a kind of drawing in three dimensions. I start with fragments – familiar, found, improvised – and then build up to complex structures that invite the oibserver to consider such matters as memory, invention and metaphor."

From a catalogue at Galerie Besson, 1990

Ewen Henderson

Two Megaliths
1993
110 cm

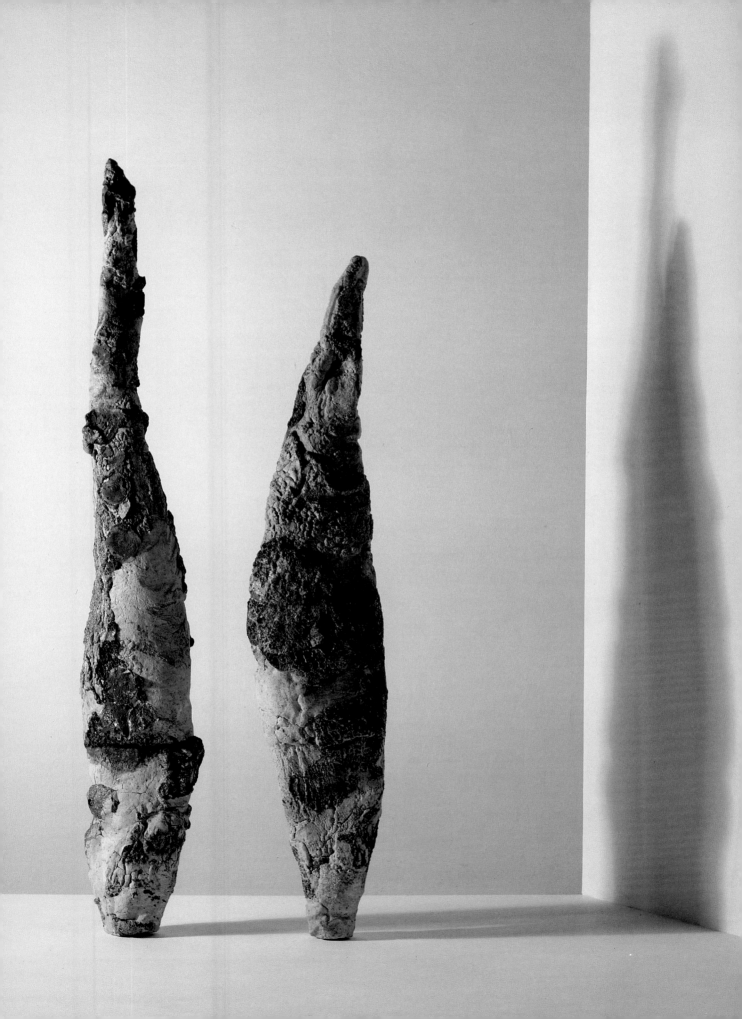

"I am involved in how women have been portrayed in Western art history: women are continually reinvented and mythologised in painting and sculpture, depending on the dominant ideology of the time.

Women, and images of women, have also been restricted in fashion and design. I use the 'dress' as a metaphor to express the feeling of constraint. It is a fact that the "desirable" shape of women has been physically determined and reflected through the confines of fashion and dress.

Through surface texture and colour, the "feminine" bodices and corsets are transformed into metallic-looking objects which appear as recently-found relics or armour from antiquity. I make references to the sculpture of ancient Greece, since this period forms the basis of modern, Western society. Then, the male nude predominated and the female figure was usually draped.

My pieces often reflect the drapery of these sculptures, and through pose and gesture ask questions about the role of the dressed and undressed women depicted today."

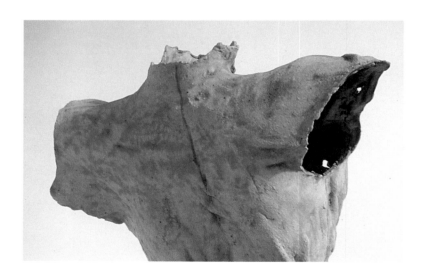

Tracey Heyes

Grecian
1993
52 x 23 cm

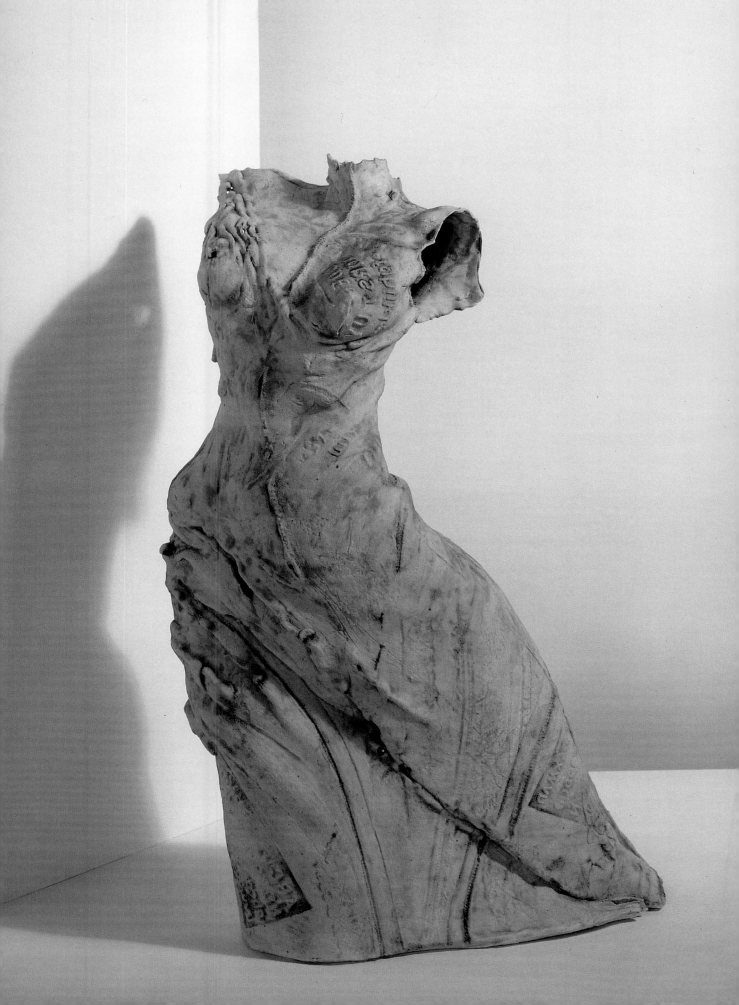

"When we walk down the street not only the buildings testify to our constructed environment but every dog, cat, shrub, and flower, has been bred, transplanted, or cultivated. And evident in all of this is the shaping hand of the artist."

Fella
1990
175 x 64 x 47 cm

Jefford Horrigan

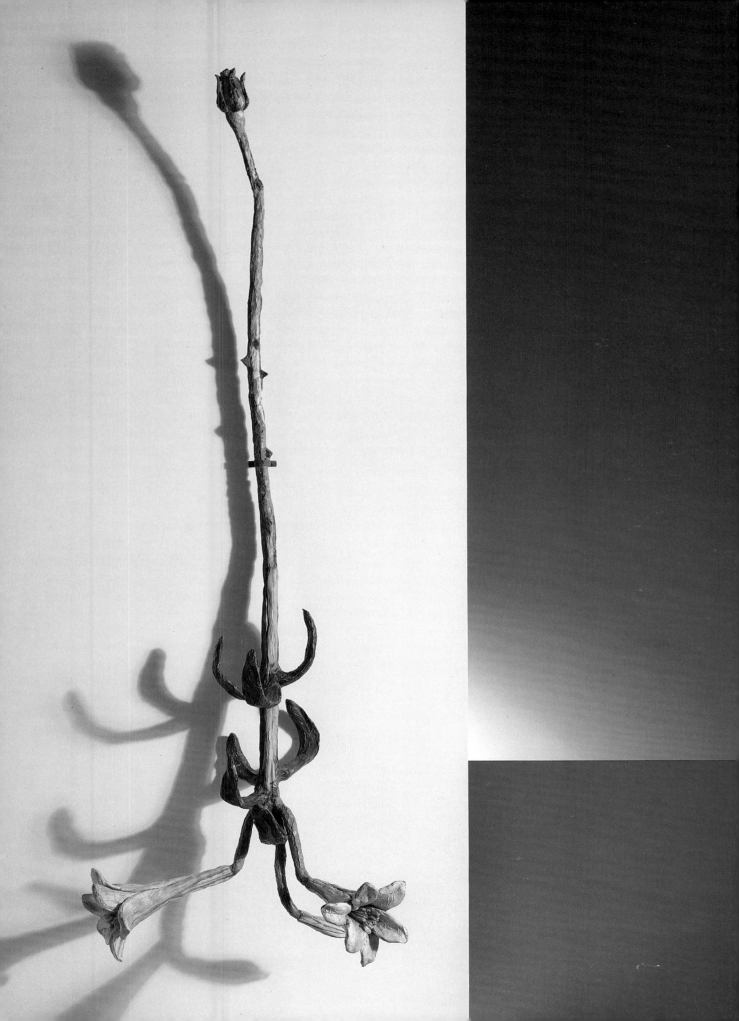

In all forms the work is about abstraction.
The business of approximating feeling with
form; giving an indirect shape, or a visual
gesture in the right direction, to complicated
notions and experiences of life. There is a lot
about gender in this work, sex without
misogyny, and procreation as a parallel to art.
Intuition, traditionally a feminine aspect, is
what drives the paintings and sculptures into
being, The harshness of their form is perhaps
contradictorily masculine – the ruthless simplicity
of shapes, great spikes piercing space and
skewering things together.

**Extract from <u>Contemporary Applied Arts</u> leaflet,
by Alison Britton, April 1988**

Bryan Illsley

Man with a Pigtail
1989
160 cm

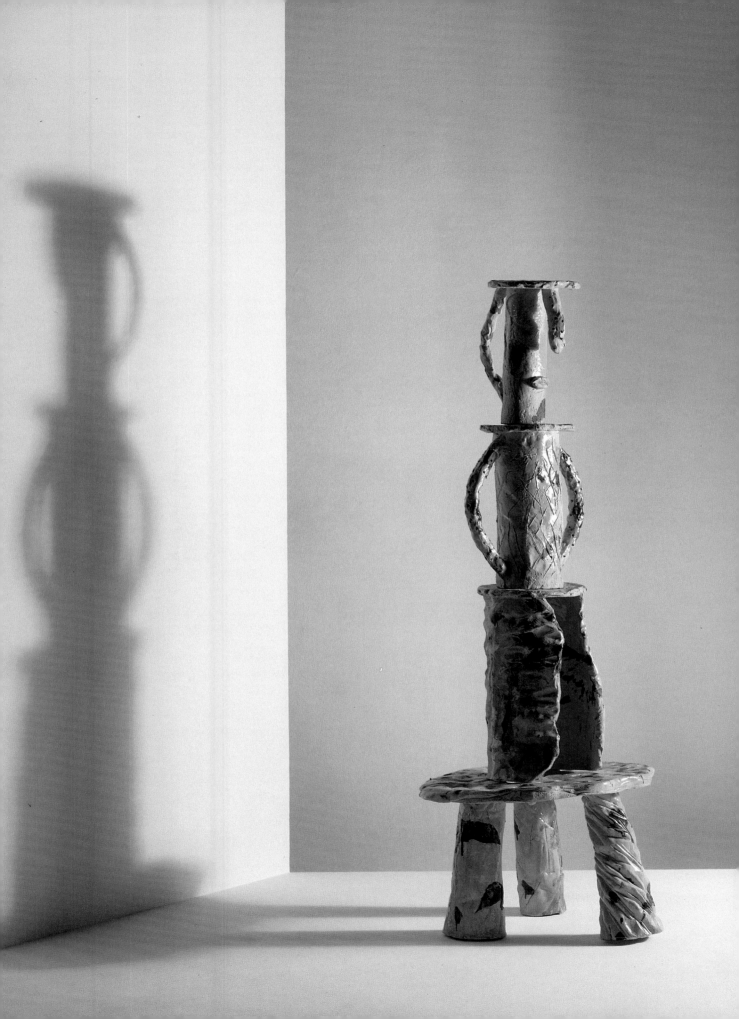

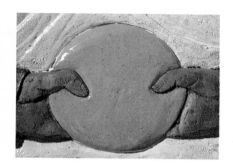

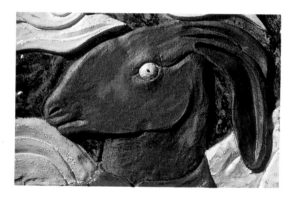

"I was brought up in Hong Kong and Britain and have been influenced by both Chinese traditional ceramic sculpture and European art. Initially, my subject matter came from Chinese mythology, but now I have created my own; recent pieces have taken on a more dream-like view of the world. Surreal images are seen as part of stories as yet unfinished, their mysterious and unexpected form as important as recognition of the familiar. Ideas of reality and myth coexist, and acceptance of the strange as normal. These themes are, I feel, common to much Chinese art."

Pamela Leung

The Wall

1990

180 x 120 x 30 cm

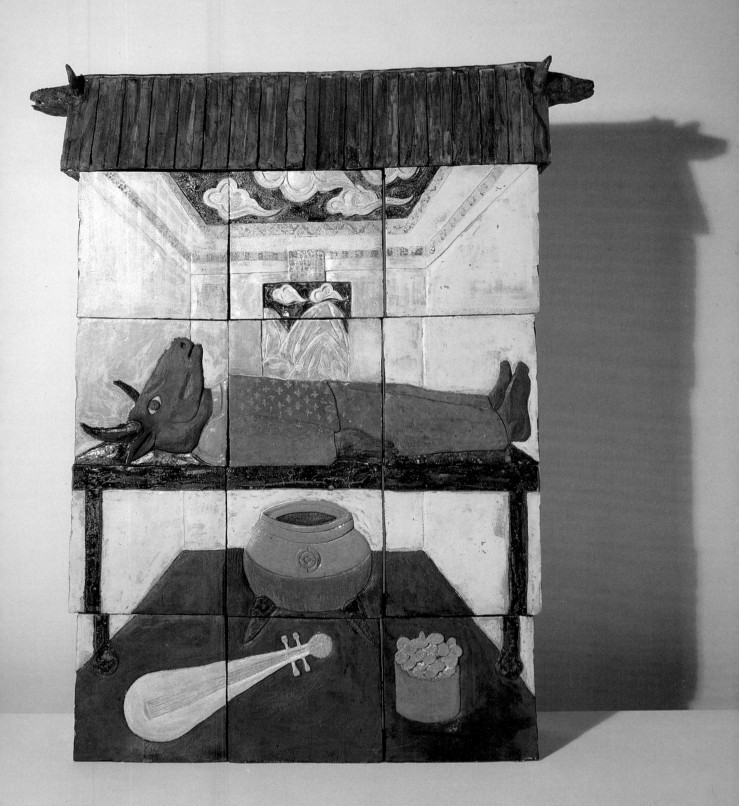

"My work is about process and the random relationships of different materials; about the fibre of loofahs fossilized; the hardened remains left after firing. Their ambiguity is important. Their forms are dictated by the structure of the plant"

Hook Figure
1991
135 cm

Gillian Lowndes

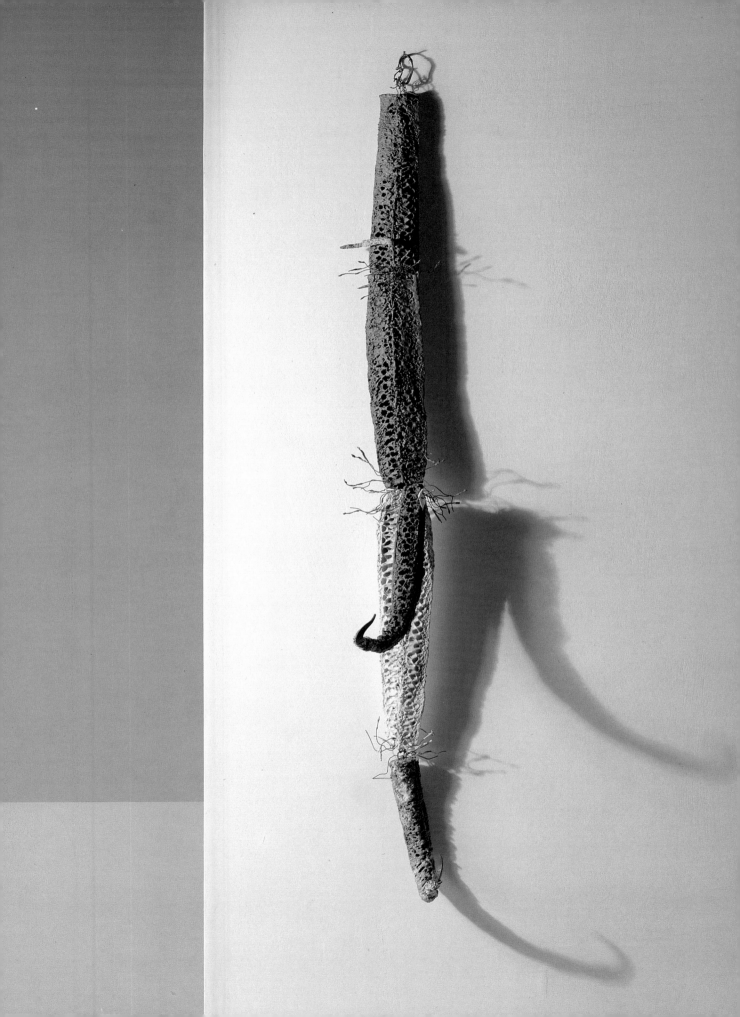

"I don't look very elegant, I don't behave very elegantly, but I think, as a kind of a joke, a kind of a reversal, that I like to make elegant things."

Extract from <u>Crafts</u> No 80, May 1986

Bruce McLean

Jug

1986
53 x 41 x 6 cm

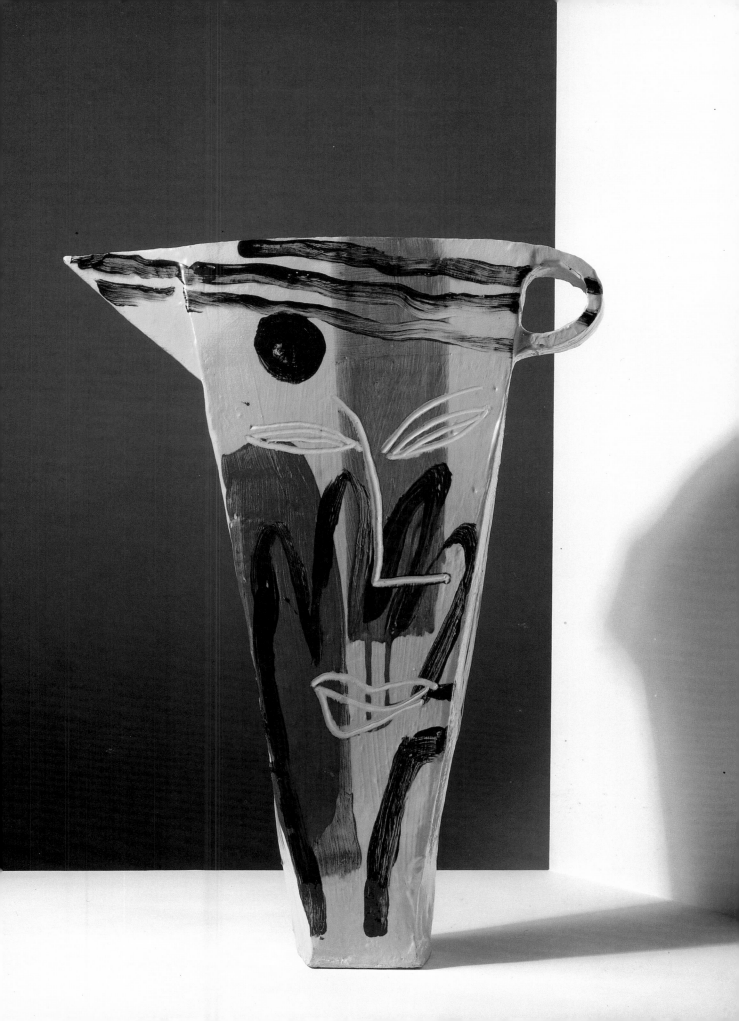

Carol McNicoll returned from a trip to India recently with an altered, and much more negative, view of the English craft world. She had seen extraordinary things made unselfconsciously and for some purpose in India, without any of the pretensions that we have. Her work continues, but she only wants to make things that are cast and in series, and has abandoned the one-off pieces that now seem too precious.

Alison Britton

Carol McNicoll

Ladakh Tulip Pot

1993
25 cm

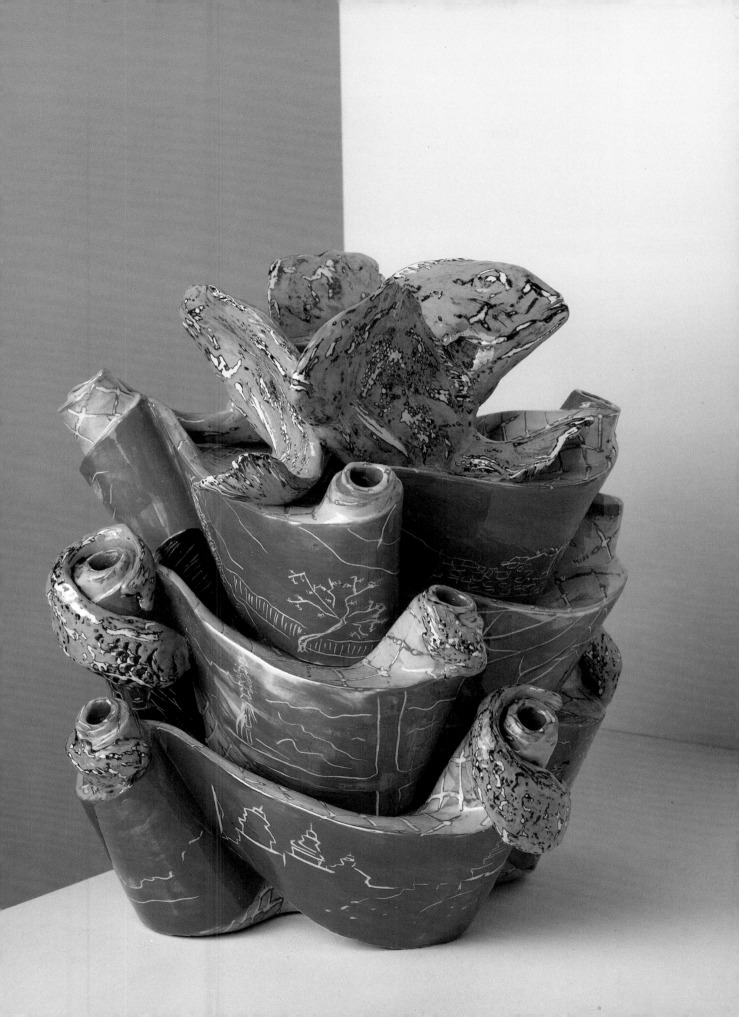

"I think the current concerns in my work are multi-faceted. By portraying the natural world I'm celebrating nature and her various aspects with one of her most wonderful materials, clay.

Building, marking, forming, transforming clay into animal forms are methods of expressing my own nature. The works reflect my own condition as a human being and states of mind."

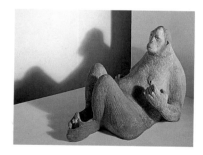

Rosa Nguyen

Sacred Cow Head
1993
25 cm

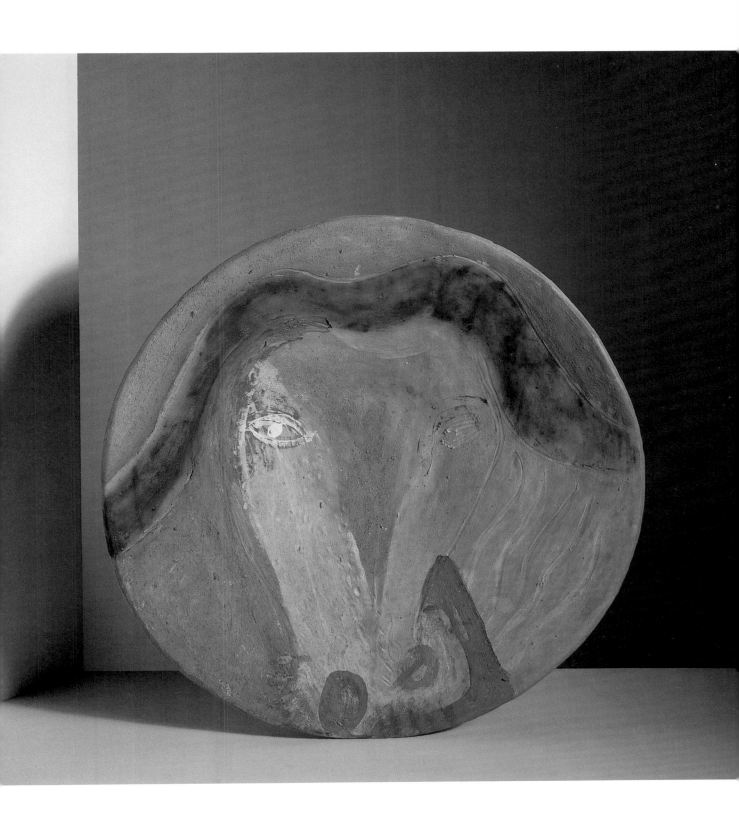

"Within the disciplines of throwing and hand building I have sought to examine the formal values of both movement and endurance using a variety of clays..." Movement, endurance and risk are engaged with as subject matter and as physical realities. These pots are stretching both material and process to the limit, and in their thin-skinned delicate making predict the forthcoming ordeal of firing. The links between spiritual and mineral properties, and Yoruba roots and London life, are the source of energy in this work. Personification in the pot forms is clearly evident – this family of red pots are observers.

Alison Britton

Lawson Oyekan

Wrapped Pot

1992

80 x 20 cm

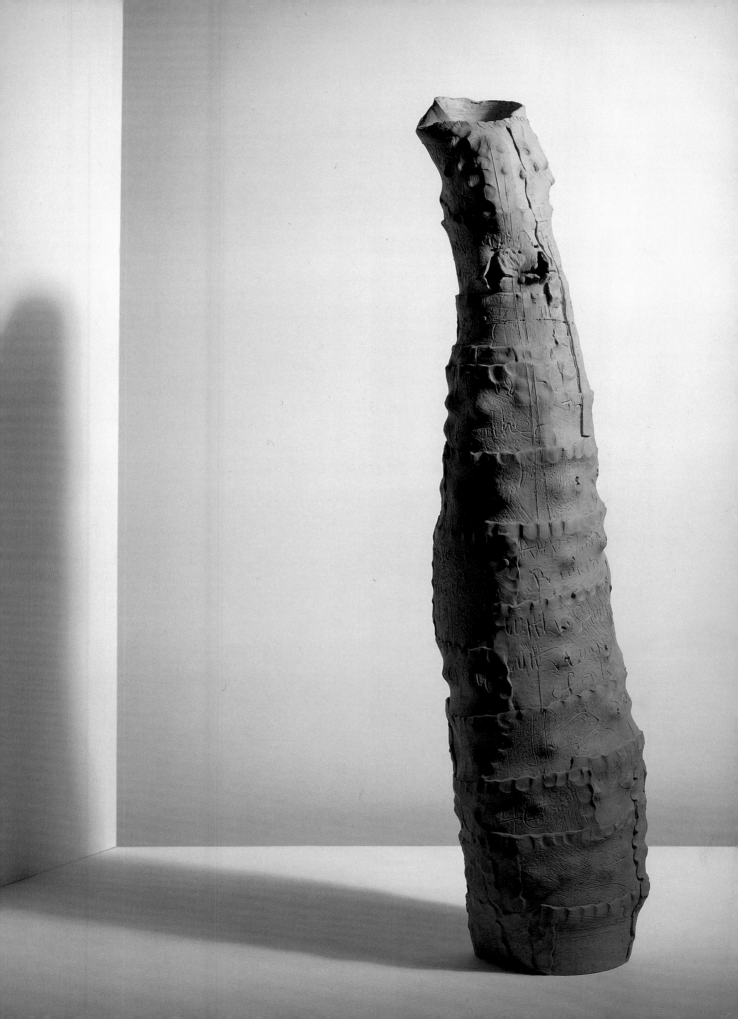

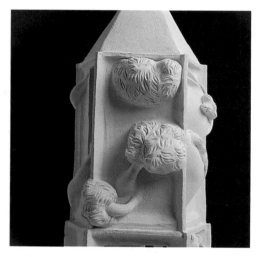

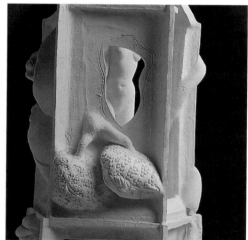

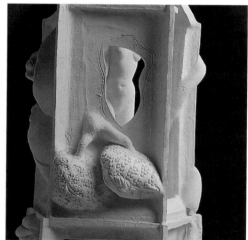

Trupti Patel

"I find clay to be a most direct and tactile material. It gives shape to my imagination. In India I worked with plaster, fibreglass, bronze and clay. It was clay which offered me an intrinsically organic and earthy method of expression.

At the Royal College of Art, I concentrated on studying the medium. Since 1987, I have been working specifically to stretch the qualities of the material to my advantage. Various figures, trees and other reliefs followed. The reliefs offered a possibility of pictorial space. When I stacked some works together a few years ago, I did not know it would lead me to explore what eventually became a pillar.

My interest is to create the world of feelings with a niche for every thought. The pentagon shape of the column created a better presence in space. Each individual relief forms part of the total work, leading to a spiral movement. The low, high and interwoven forms create a sense of space, light and pondering of the visual world. It often results in hide and seek played not so much with one's eyes as in the mind."

'Journey' column IV

1992
205 x 40 cm

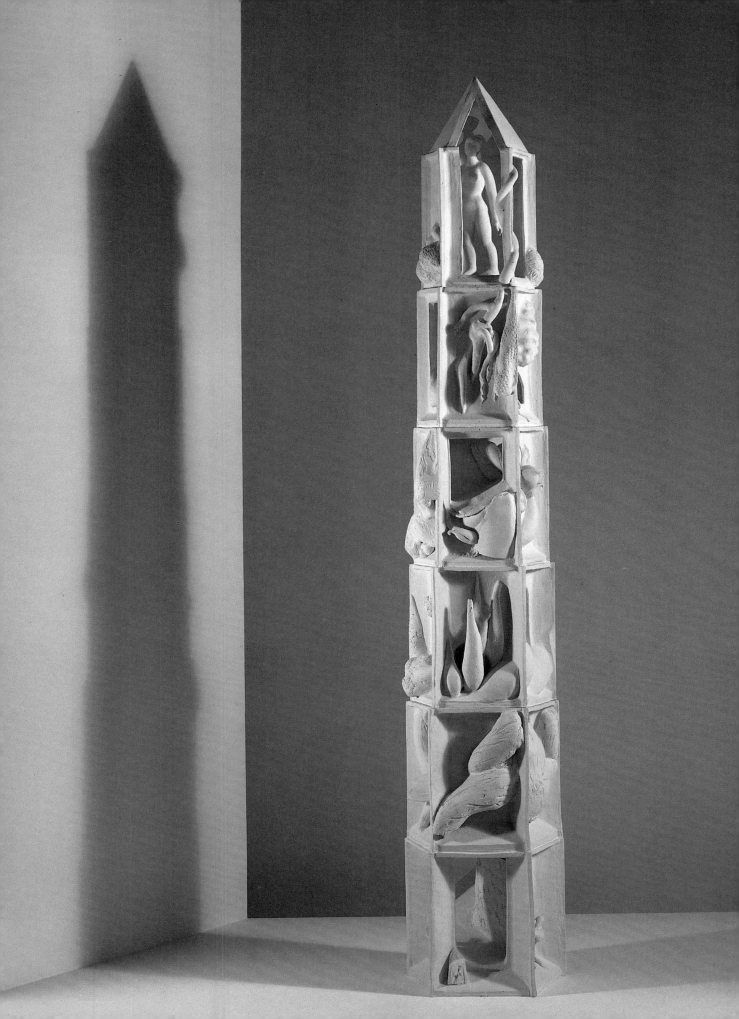

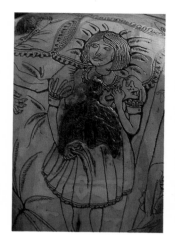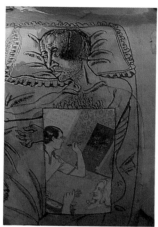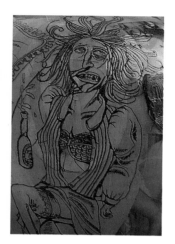

"Rude confession has become a tired habit within me, which I try to curb, but find myself only delving more carelessly inward, creating a myth of what I like to imagine is the inner me. I am only brought back to reality by the observation that I am constantly contradicting, and conflicting with, my sincerest beliefs."

Grayson Perry

Childhood Trauma Manifesting Itself in Later life

1992
34 x 33 cm

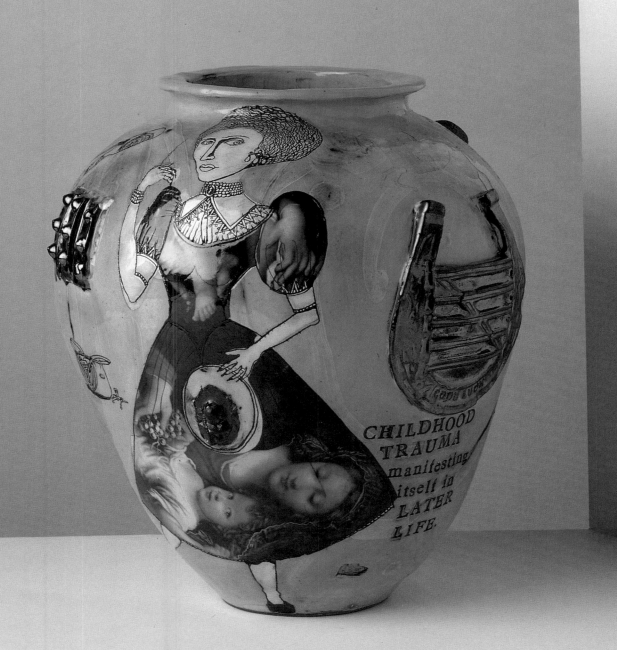

"These objects are representative of a group of work that made direct reference to the human body. I wished the relationship between the viewer and the object to shift from the analytical to the emotional through a shared familiarity. The objects are closed, tattooed or scarred, part of a whole, or mutilated; simultaneously ugly and beautiful according to our belief in the normal."

Jacqueline Poncelet

Object 'Against the Wall'

1985
105 x 40 x 35 cm

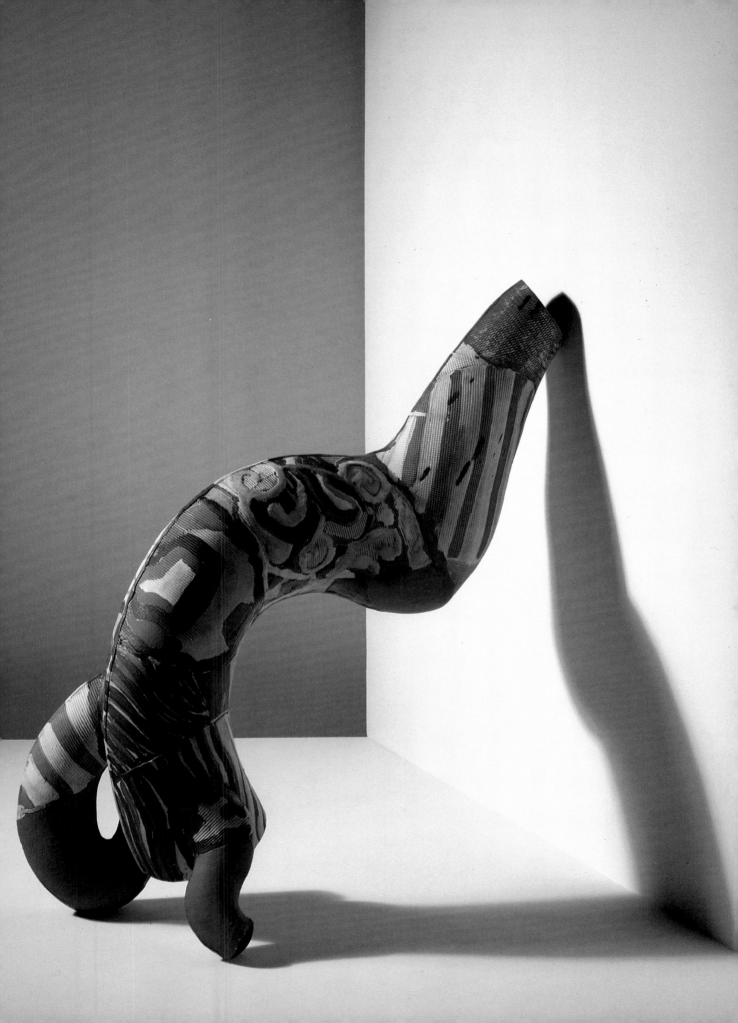

"This work is part of a series involving exploration of enclosed volumes: caskets without lids, vessels with vestigial openings, the potential space of hidden interiors. In the leaning pieces form is pared away, propped up — an attempt at a kind of non-form, in which references to physical and emotional states are just retained."

Sara Radstone

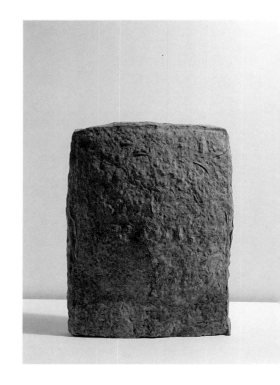

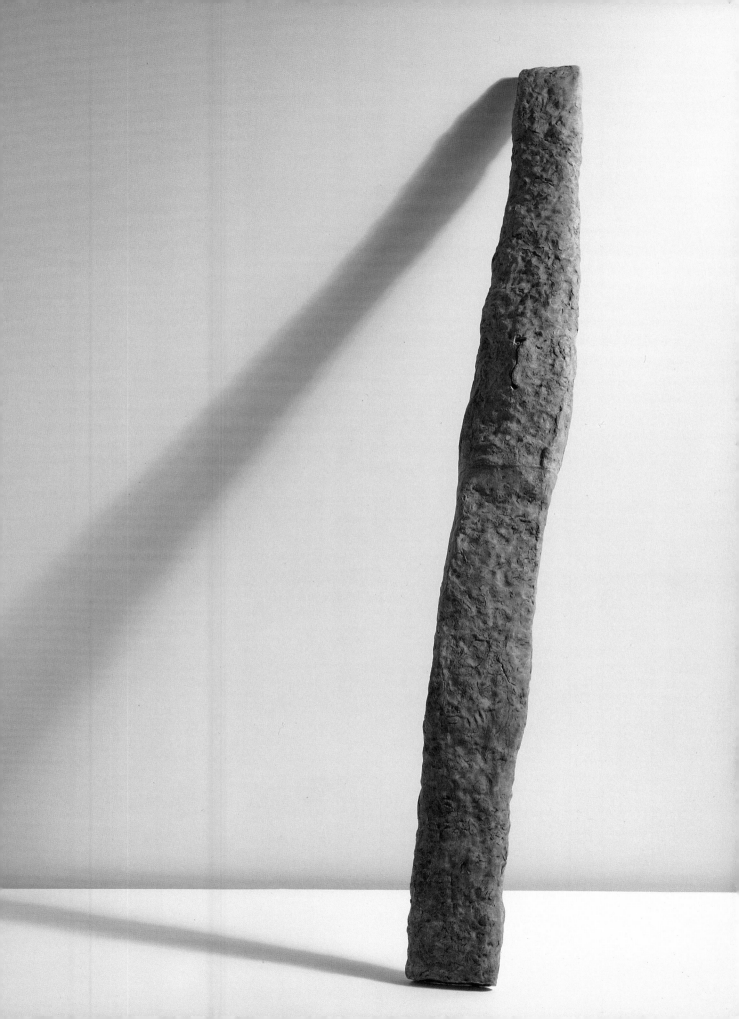

The first figurative works of Sarah Scampton remained very close to pots, because of the way in which they were constructed and because the figures themselves were involved with a pot form – hugging it or supporting it in some way on the body. The anthropomorphism that lurks in so many pots throughout history is extended into the dual image of man clutching bowl. In these new works the vessel has departed, and instead the symbiotic relationship is between two humans, parent and child. In one piece a couple are sandwiching their child between them. The work is tending now to less literal representation – figures are partly disappeared, or abstracted, drawing attention to the bond itself as the subject rather than the people.

Alison Britton

Sarah Scampton

Mother and Child
1993
87 x 90 cm approx

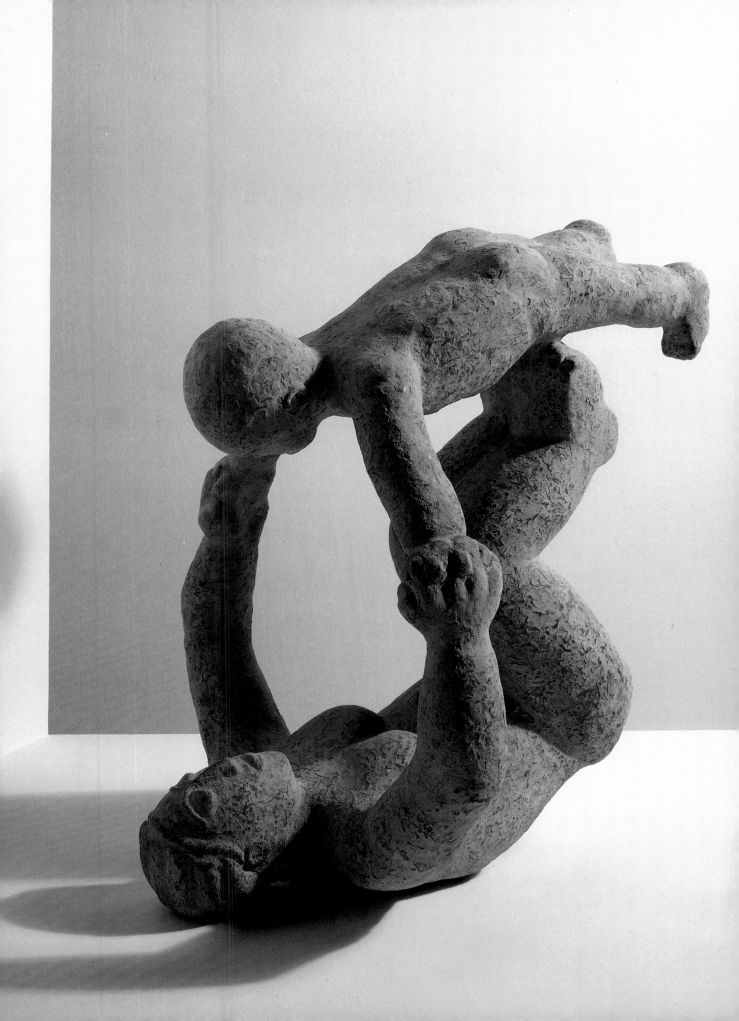

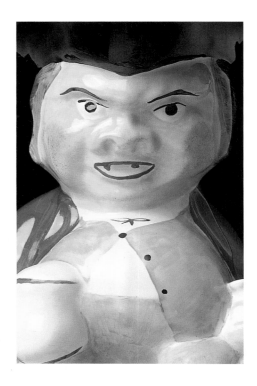

"The English thing was a mixture of a few ideas: 1. I was fascinated by preconceptions when I travelled around foreign countries – about having your own views of a culture confirmed or rejected. We have a certain idea of the French, for example, which we have arrived at and which is most certainly wrong. 2. Little England, jingoism, nationalism. 3. Middle class suburbia. 4. Thatcherism, Majorism... the play on Englishness is always there with these. Every speech Major gives has an English proverb in it. I found it so interesting that he does that, that I went and bought a book of proverbs...

I started looking at things like Mock-Tudor, and pewter seems very very English to me. The Toby Jug is a completely English aberration. There is a particular thing about the Toby Jug which is to do with a romantic Englishness, the John Bull figure, angry and aggressive. The Punch figure came out of that, another English symbol."

Extract from a conversation with Paul Greenhalgh in <u>Studio Pottery</u>, February 1993

Richard Slee

Toby Jug
1992
45 cm approx

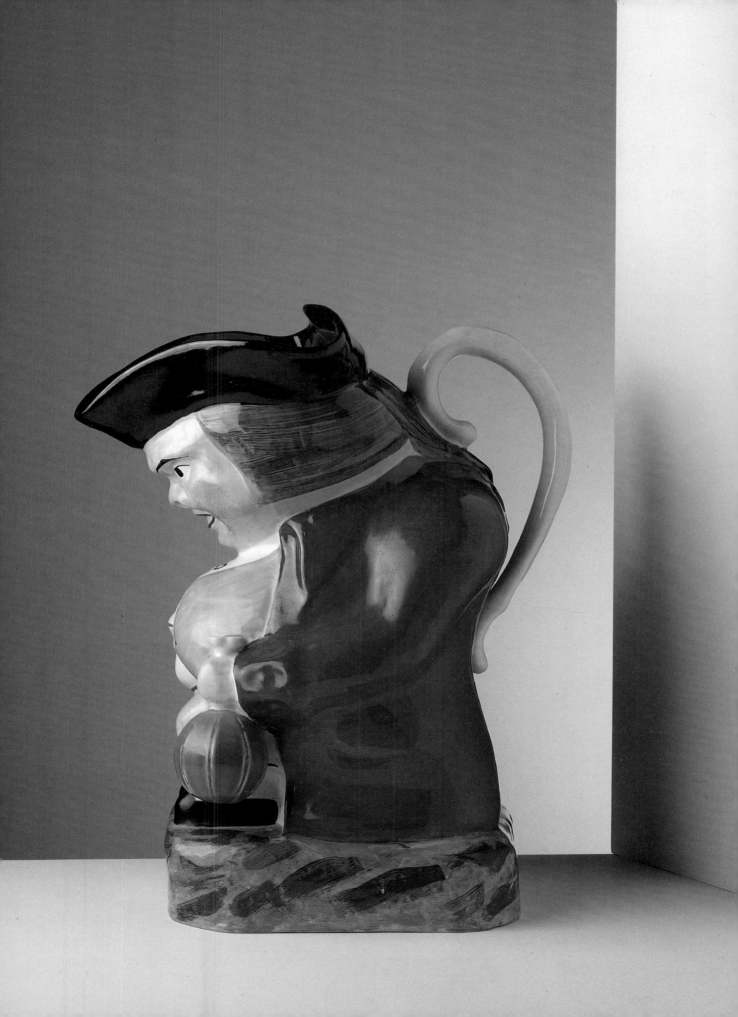

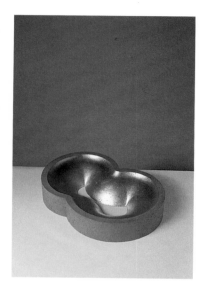

Igor Stravinsky said: "My freedom consists in my moving about within the narrow frame that I have assigned myself for each one of my undertakings. I shall go even further: my freedom will be so much the greater and more meaningful the more narrowly I limit my field of action and the more I surround myself with obstacles. Whatever diminishes constraint diminishes strength. The more constraints one imposes, the more one frees one's self of the chains that shackle the spirit."

From Stravinsky's Harvard lecture series, <u>The Poetics of Music</u>, 1939-40

Martin Smith

Substance and Shadow No IV
1993
40 cm

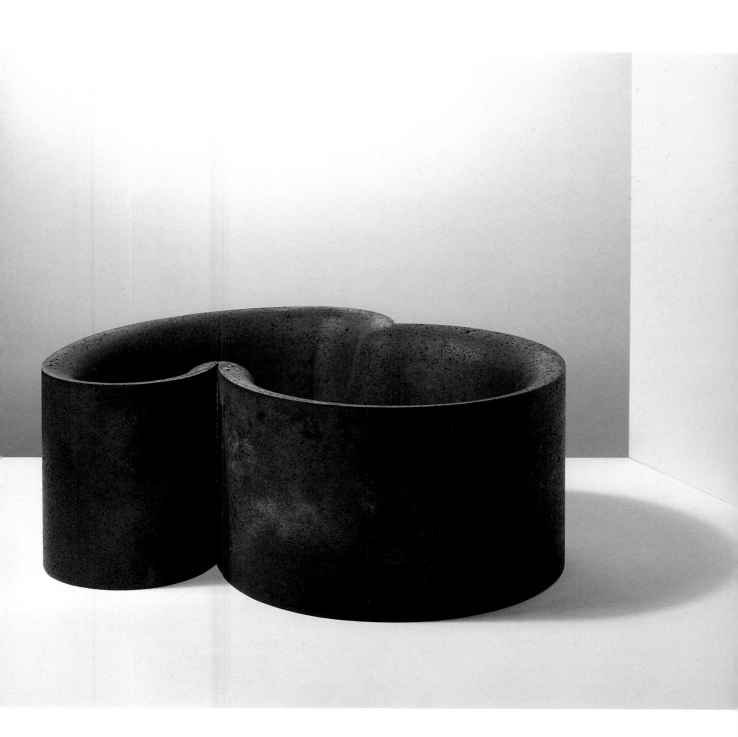

"I always rely on personal attitudes to life. I
hate the way things are at the moment. My
work is saying, I don't agree, I don't believe in
what is happening. It is a reaction against. The
government is stripping everything down to function,
but life is richer than that. So I am looking at ritual
things and in my work putting on things that have no
relation to function."

Extract from <u>London/Amsterdam: New Art Objects from
Britain and Holland</u>, catalogue 1998

Angus Suttie

Pot

1989
39 cm

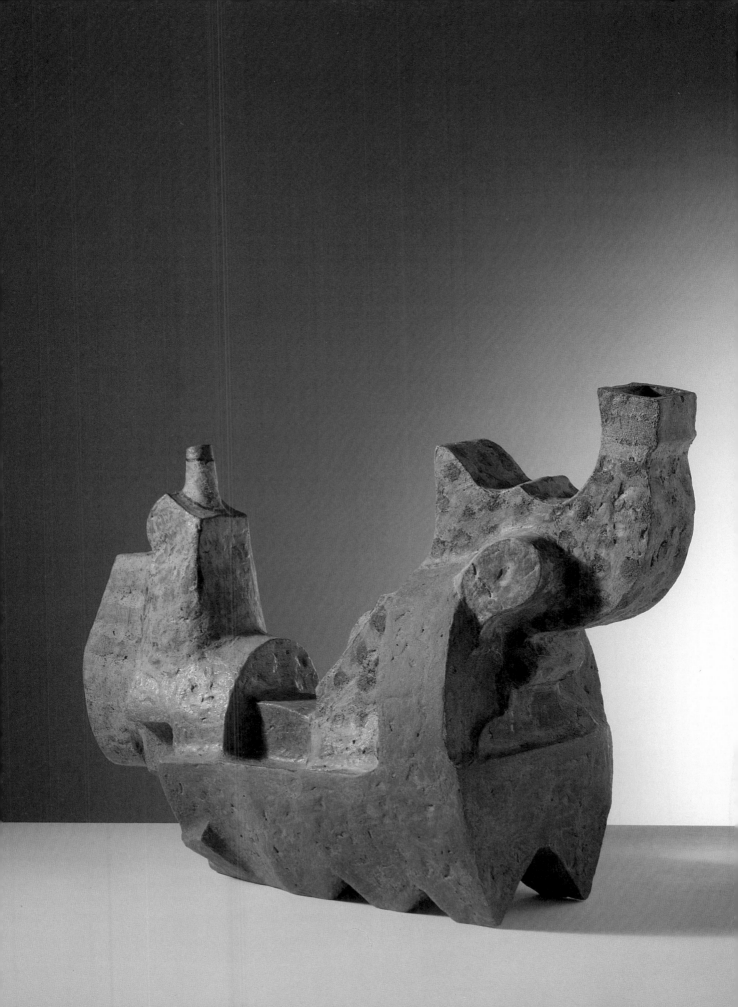

biographies

Paul Astbury

Born 1945, Cheshire, England
Lives and works in London.
Studied 1962-68 Stoke-on-Trent College of Art
1968-71 Royal College of Art, London
1991- Head of Ceramics and Glass, Middlesex University
Awards from 1974 Crafts Advisory Committee
1977 British Arts Council
1984 Crafts Council.

Selected Exhibitions [*denotes solo exhibition]
1972 Clay Sculpture, Midland Group Gallery, Nottingham
1973 Astbury/Shannon/Rowe, Crafts Advisory Committee, London
1974-77 Ceramic Forms, Crafts Council/British Council touring Exhibition, Europe
1974 Chunichi International Exhibition of Ceramic Art, Nakamura Art Gallery,
Nagoya, Japan; New Ceramics, Ulster Museum, N.I Arts Council Touring Exhibition*
1974-75 Ceramic Forms, Crafts Advisory Committee and British Council, touring in
Europe
1975-76 Ceramic Forms, Crafts Advisory Committee and British Council, touring in
Poland
1978 Marked Surfaces, British Crafts Centre, London
1978-80 State of Clay, Sunderland Arts Centre and tour
1979 Marked Surfaces II, Everson Museum, N.Y. USA*;
Ceramic Forms, Crafts Advisory committee and British Council, touring in
Scandanavia; New Works, Octogon Gallery, Belfast
1979-1981 Image and Idea, British Council touring exhibition of Australia and New
Zealand
1980 Clay Sculpture, Yorkshire Sculpture Park
1981 British Ceramics and Textiles, Knokke-Heist, Belgium
1984 Enhanced Image/Chairs and Circles, Aberystwyth Arts Centre, University College
Wales*
1986 Surface to Surface, Turnpike Gallery, Leigh; Ceramics, Northern Centre of
Contemporary Art, Sunderland
1987 The Great Midwest International Painting Exhibition, Warrensburg, USA
1988 Out of Clay, Manchester City Art Museum
1989 Off the Wheel, Whitworth Art Gallery, Manchester
1990 Space and Form, Rufford Park Gallery, Rufford
1993 On the Edge, Kettle's Yard and Aberystwyth Arts Centre and touring.

Collections
Crafts Council, London
Inner London Education Authority
Libertys, London
North West Arts Association
Portsmouth Museum and Art Gallery
Southampton Art Gallery
Ulster Museum, Belfast
Everson Museum of Arts, New York
Rohss Museum, Gothenburg
Nakamura Art Gallery, Nagoya, Japan
Thomas Hellburg Collection, Sweden
Catcleugh, Ismay, Rothschild and Firth private Collections
Aberystwyth Arts Centre, University College Wales
Institute for the History of Ceramic Art, Los Angeles.

Selected Bibliography
E. Lewenstein and E. Cooper, New Ceramics, 1974
Art and Artists, July 1978
P. Lane, Studio Porcelain, Pitman Publishing Ltd, 1980
K. McCready and J. Axel, International Contemporary Study of Porcelain – Traditions
and New Visions, Watson-Guptill Publications, 1981

M. Casson, 'British Ceramics', Ceramics Monthly, February, 1982
C. Speight, Images in Clay Sculpture, Harper and Row, London, 1983
Ceramica, Vol. 18, May, Spain, 1984
C. Speight, Hands in Clay, Mayfield, 1989
G. Flight, Ceramics Manual, B.L.A. Publishing Ltd, 1990
R. Zakin, Ceramics : Mastering the Craft, A.C. Black, 1991
I. Gregory, Sculptural Ceramics, A.C. Black, 1992.

Gordon Baldwin

Born 1932, Lincoln
Lives and works in Eton, Berkshire.
Studied Lincoln School of Art
1950-53 Central School of Art and Design
1992 awarded OBE.

Selected Exhibitions [*denotes solo exhibition]
1961 Primavera, London
1963 Leicester Galleries, London
1969 Seibu Gallery, Tokyo, Japan
1970 Oxford Gallery*
1971 Modern British Ceramics, Koster Gallery, Germany
1972 International Ceramics, Victoria and Albert Museum, London; International
Ceramics, Faenza, Italy
1973 The Craftsman's Art, Crafts Advisory Committee at the Victoria and Albert
Museum, London; British Twentieth Century Ceramics, Liverpool
1974 British Crafts Centre, London; Ceramic Forms I, Crafts Advisory
Committee/British Council touring in Europe
1975 Ceramic Forms II, Crafts Advisory Committee/British Council touring in Poland;
Kettle's Yard, Cambridge;
1976 British ceramics, Pennsylvania State university, USA
1977 British potters, Graham Gallery, New York
1978 The State of Clay, Sunderland Arts Centre and touring; Carmel College,
Wallingford*
1979 Takashimaya gallery, Tokyo; Keramic Gallery, Cologne
1980-81 Image and Idea, British Council touring, New Zealand and Australia
1981 British Ceramics and Textiles, Knokke-Heist, Belgium
1983 Gordon Baldwin : A Retrospective View, Cleveland County Museum Service,
touring in UK*
1984 Eight Ceramicists, British Crafts Centre, London; Artist Potters Now, Oxford
County Museum Service;
1985 British Ceramics, Keramion, Frechen, West Germany; British and German
Ceramics, Fitzwilliam Museum, Cambridge
1986 Gordon Baldwin, The Solomon Gallery, London*; American and British Ceramics,
Smith Gallery, London
1987 Palazzo Agostinelli, Bassano del Grappa, Italy
1988 Contemporary Ceramics, Painting and Sculpture, Sheila Harrison Fine Art,
London; New Art Objects London-Amsterdam
1989 Gordon Baldwin – New Ceramics, Contemporary Applied Arts, London*;
Retrospective, Boymans Museum, Rotterdam; L'Europe des Ceramistes, St Germain
d'Auxerre, Puisaye
1990 Space and Form, Rufford Craft Centre, Newark, Nottinghamshire; Hetjens
Museum, Dusseldorf*; Galerie Bowig, Hanover, Germany*
1991 14 British Potters, Galleria Il Giardino Dell'Arte, Bologna, Italy; The Abstract
Vessel, Oriel Gallery, Cardiff; Beyond the Dovetail, Crafts Council Gallery, London;
Colours of the Earth, British Council Exhibition touring India; British Ceramics Bellas
Artes Santa Fe; International Ceramics, Korea; Configura 1, Erfurt, Germany
1992 British and Dutch Ceramics, Rufford Craft Centre, Nottingham then Amsterdam;
with Nancy Baldwin, Alpha House Gallery, Sherbourne; Germany, England and Japan,
Frankfurt; International Ceramics, Fulda, Germany
1993 CAA Gallery, London*.

Collections
Victoria and Albert Museum, London
Crafts Council, London
Southampton City Art Gallery
Leicester Education Authority
Greater London Council
Portsmouth City Museum and Art.Gallery
Usher Gallery, Lincoln
Abbot Hall Art Gallery, Kendal, Cumbria
Paisley Museum and Art Gallery
Museum Boymans Van Beuningen, Rotterdam
Bellrive Museum, Zurich
Penn State University, USA
Shipley Art Gallery, Gateshead
Swindon Museum and Art Gallery
National Gallery of Victoria, Melbourne, Australia
Knokke-Heist, Belgium
Glasgow Museum and Art Gallery
Octagon Centre, Iowa, USA
Keramion Centre, West Germany
Kettle's Yard, Cambridge
Cleveland County Museum Service
Southern Arts, Winchester
Buckinghamshire County Museum
Wurttembergisches Landesmuseum, Stuttgart
University College Wales, Aberystwyth
Museum fur Keramik, Deidesh0eim
Nordenfjeldske, Kunstindustrimuseum, Trondheim
Museum de Ceramica, Barcelona
Los Angeles County Museum of Art
Shigaraki Ceramic Cultural Park, Japan.

Selected Bibliography
C. Spencer, The Painter and Sculptor, Vol 2, No 3, 1959
T. Birks, Art of the Modern Potter, Country Life Publications, 1976
V. Margrie, review of Gordon Baldwin at Contemporary Applied Arts, Crafts 99,
July/August 1989
E. Cooper, review of Gordon Baldwin at Rufford Craft Centre, Crafts 105, July/August
1990
T. Harrod, review of the Abstract Vessel, Crafts 111, July/August 1991.

Stephenie Bergman

Born 1946, London
Lives and works in France.
Studied 1963-67 St Martin's School of Art, London
1969-71 Federal Penitentiary for Women, West Virginia, USA
1975-77 Gulbenkian Foundation Award.

Selected Exhibitions [*denotes solo exhibition]
1973 Garage Art Ltd, London*
1975 Stephenie Bergman and Nick Pope, Southampton Art Gallery and Mappin
Gallery, Sheffield; Garage Art Ltd, London*
1976 Midland Group, Nottingham*; 25 Years of Painting, Royal Academy, London
1977 IX Festival International de la Peinture, Cagnes-sur-Mer, France; Kettles Yard,
Cambridge*
1978 Tolly Cobbold 2, UK tour; Certain Traditions, recent British and Canadian Art,
British Council, Canada and UK tour; Anthony Stokes, London*
1979 British Art Show, UK tour; Style in the Seventies, UK tour
1980 Tolly Cobbold 3, UK tour; XI Biennale de Paris; Selections from XI Biennale de
Paris, Belgrade; Anthony Stokes, Riverside Studios, London*
1981 The Maker's Eye, Crafts Council Gallery, London
1982 Fabric and Form, Crafts Council/British Council, Crafts Council Gallery, and
foreign tour; Salon des Femme Peintres, Musee du Luxembourg, Paris
1983 Whitechapel Art Gallery, open exhibition
1984 2nd Textile Biennale, Vehta, Belgium; Stephenie Bergman, Crafts Council
Gallery, London*
1985 14th John Moores Exhibition, Liverpool; Craft Matters, John Hansard Gallery,
University of Southampton.
1987 Nigel Greenwood Gallery, London.

Selected Bibliography
F. Crichton, Art International, vol, 19 Sept 1975 p.54
G. Pollock and R. Parker, Old Mistresses, Women, Art and Ideology, Pandora, London,
1981
P. Barnett, Art or Craft... Who Decides?, Craft Matters, John Hansard Gallery, 1985.

Alison Britton

Born 1948, London suburbs
Lives and works in London.
Studied 1966-1967 Leeds College of Art
1967-1970 Central School of Art and Design, London. Dip AD in Ceramics
1970-1973 Royal College of Art, London. MARCA in Ceramics
Teaching part-time, Ceramics and Glass Department, Royal College of Art, London
1987 Co-organiser of Ceramisti Inglesi a Bassano. Introduced exhibition in Bassano del
Grappa
1993 Canada Council Visiting Artist, lecturing at Harbourfront Centre, Toronto;
Concordia University, Montreal; and Nova Scotia College of Art and Design, Halifax.

Selected Exhibitions [*denotes solo exhibition]
1976 Amalgam Gallery, Barnes, London*
1978 Galerie Het Kapelhuis, Amersfoort, Holland, with Jacqui Poncelet; Five English
Potters, Princessehoff Museum, Leeuarden, Holland
1979 Jugs and Aprons, Aberdeen Art Gallery and Museum. with Stephenie Bergman;
The Work of Alison Britton, Crafts Council, London*
1981 Prescote Gallery, Banbury*
1982 Galerie L, Hamburg, Germany, with Jacqui Poncelet
The Maker's Eye, Crafts Council, London AB was one of fourteen selectors
1983 Fifty Five Pots, Orchard Gallery, Londonderry, N. Ireland; Pots and Tables,
Aspects Gallery, London, with Floris Van den Broecke; Oxford Gallery, Oxford, with
Bryan Illsley paintings
1984 Westminster Gallery, Boston, USA, with Jacqui Poncelet; British council touring
exhibition (Czechoslovakia),British Ceramics, curated by AB
1985 Miharudo Gallery, Tokyo, Japan*; Fast Forward : New Directions in British
Ceramics, Institute of Contemporary Arts, London; Kapelhuis Gallery, Amersfoort,
Holland, with Jacqui Poncelet, Richard Slee, and Carol McNicoll; British Ceramics,
Kruithaus Museum, Den Bosch, Holland
1986 British Ceramics, Dorothy Weiss Gallery, San Fransisco; Our Domestic
Landscape, Cornerhouse Gallery, Manchester
1987 Ceramisti Inglesi a Bassano, Six British ceramic artists, Palazzo Agostinelli,
Bassano del Grappa, Italy;
The Vessel, Serpentine Gallery, London, curated by Anthony Stokes; Alison Britton,
New Ceramics, Contemporary Applied Arts, London*
1988 British ceramics, Garth Clark Gallery, Los Angeles, USA, and Galleries of San
Fransisco Airport; Contemporary British Crafts, National Museum of Modern Art,
Kyoto, and National Museum of Modern Art, Tokyo, Crafts Council; Galerie Het
Kapelhuis, Amersfoort, Holland, with Robert Marsden and Maria van Kesteren
1989 L'Europe des Ceramistes, L'Abbeye Saint-Germain d'Auxerre, France, and tour;
National Museum, Stockholm*
1990 Contemporary Applied Arts, London*;
Great British Design, Mitsukoshi department stores in Japan, organized by Design
Council, crafts curated by Martina Margetts; Lucie Rie, Hans Coper, and their pupils,
Sainsbury Centre for the Visual Arts, UEA, Norwich; Alison Britton, a Retrospective,
Aberystwyth Arts Centre, University College Wales, and touring Newport, Aberdeen,
Carlisle, Stoke on Trent, Cardiff, York also RCA galleries London and Museum
Boymans van Beuningen , Rotterdam*
1991 Fourteen British Potters, Il Giardino dell'Arte, Bologna, Italy; The Abstract
Vessel, Oriel Gallery, Cardiff, and touring; British Ceramics Now, Bellas Artes Gallery,
Santa Fe and New York; Colours of the Earth, British Council Exhibition touring India
1992 Aspects of Sculpture, Galerie Handwerk, Munich, Germany
1993 Osiris Gallery, Brussels, Belgium*

Collections
Aberdeen Museum and Art Gallery
University College Wales, Aberystwyth
Birmingham Museum and Art Gallery
Ulster Museum
British Council collection
Contemporary Arts Society
Royal Museum of Scotland, Edinburgh
Glasgow Art Gallery and Museum
Hove Museum and Art Gallery
Temple Newsam House, Leeds
Leicester Museum and Art Gallery
Crafts Council Collection, London
Victoria and Albert Museum, London
Cleveland Crafts Centre, Middlesborough
Paisley Museum and Art Gallery
York City Art Gallery
Australian National Gallery, Canberra
Art Gallery of Western Australia, Perth
The Powerhouse Museum, Sydney
Kunst and Gewerbe Museum, Hamburg
Stedelijk Museum, Amsterdam
Princessehoff Museum, Leeuarden
Museum Boymans van Beuningen, Rotterdam
Kruithaus Museum, Den Bosch
National Museum of Modern Art, Kyoto
Nordenfjeldske Kunstindustrimuseum, Trondheim

National Museum, Stockholm
Los Angeles County Museum of Art.

Selected Writing
The Maker's Eye, Crafts Council, London, 1982
'The Modern Pot', Fast Forward, ICA publications, London, 1985
P.Dormer, The New Ceramics, Introduction, Thames and Hudson, London, 1986
'The Story so Far', Ceramic Review, May-June 1991
'The Urban Potter', Colours of the Earth, British Council, 1991
'The Manipulation of Skill on the Outer Limits of Function', Beyond the Dovetail, Crafts Council, London, 1991
'Sustaining Alternatives', M. Margetts, International Crafts, London, 1991.

Selected Bibliography
J. Houston, The Work of Alison Britton, Crafts Council London, 1979
L. Adamson, 'Jugular Vein', The Guardian, January 5 1980
The Maker's Eye, Crafts Council, London, 1982
Fifty five pots, Orchard Galley, Londonderry, 1983
P. Dormer, Alison Britton in Studio, photography by D. Cripps, Bellew Publishing, 1985
T. Harrod, Art into Object, John Hansard Gallery, Southampton, 1985
P. Dormer, The New Ceramics : trends and traditions, Thames and Hudson, London, 1986
O. Watson, Alison Britton, contemporary applied arts leaflet, 1987
W. Dubin, 'Alison Britton', American Ceramics, 7/1 1988
F. Huygen, British Design, Image and Identity, Museum Boymans van Beuningen /Thames and Hudson, 1989
T. Harrod, Alison Britton, Contemporary Applied Arts leaflet, 1990
M. Drexler Lynn, Clay Today, Contemporary Ceramists and their Work, Howard and Glen Laurie Smits Collection, Los Angeles County Museum of Art, 1990
O. Watson, British Studio Pottery : the Victoria and Albert Museum Collection, Phaidon/Christies, London, 1990
T. Harrod, Alison Britton, Ceramics in Studio, Aberystwyth Arts Centre, Bellew Publishing, 1990
J. Houston, The Abstract Vessel, Oriel/Bellew Publishing, 1991
M. Margetts, International Crafts, Thames and Hudson, London, 1991.

Tony Cragg

Born 1949, Liverpool
Lives and works in West Germany
Studied 1969-72 Wimbledon School of Art
1973-77 Royal College of Art, London (sculpture)
1977 Moved to Wuppertal, West Germany
1988 Awarded Professorship Dusseldorf Academy
1988 Turner Prize winner.

Selected Exhibitions [*denotes solo exhibition]
1977 Lisson Gallery, London; RCA Degree Show, London
1979 Lisson Gallery, London*; Kunstlerhaus Weidenalle, Hamburg*
1980 Arnolfini Gallery, Bristol*; Konrad Fischer, Neubruckstrasse*; Lisson Gallery, London*; 'Aperto'80', Venice Biennale
1981 'Britain seen from the North', Whitechapel Art Gallery, London*; Von der Heydt Museum, Wuppertal*; 'British Sculpture in the 20th Century', Whitechapel Art Gallery, London
1982 'Skulpturen', Badischer Kunstverein, Karlsruhe*; Aspects of British Art Today, Metropolitan Museum, Tokyo; Indian Triennale, New Delhi; Documenta 7, Kassel; Marian Goodman Gallery, New York*; Lisson Gallery London*; Kroller-Muller Museum, Otterlo*; British Sculpture Now, Kunsthalle Luzern; 'Objects and Figures: New Sculpture Exhibition', Fruitmarket Gallery, Edinburgh
1983 Art and Project, Amsterdam*; 'Boltanski, Cragg, Cucchi, Disler, McLean, Sherman', Crousel-Hussenot, Paris; 'The Sculpture Show', Hayward and Serpentine Galleries, London; 'XVII Bienal de Sao Paulo' and Tour; 'Arcaico Contemporaneo: M Merz, T Cragg, B Woodrow', Museo del Sannio, Benvenuto; 'New Art', Tate Gallery, London
1984 Louisiana, Museum of Modern Art, Copenhagen*; 'Vier Arbeiten, 1984', Kolnischer Kunstverein, Koln*; 'An International Survey of recent painting and Sculpture', Museum of Modern Art, New York; 'ROSC', The Guiness Hop Store, Dublin
1985 'Aureola Borealis', Oslo; Staatsgalerie Moderner Kunst, Munich*; Donald Young Gallery, Chicago*; Lisson Gallery, London*; Palais des Beaux-Arts, Brussels (travelled to ARC, Musee d'Art Moderne de la Ville de Paris)*; Turner Prize Exhibition of nominated artists, Tate Gallery, London; 'The British Show', (organised by Art Gallery of New South Wales, Sydney and The British Council (travelled to Art Gallery of Western Australia, Perth; Art Gallery of New South wales, Sydney; Queensland Art Gallery, Brisbane; The National Art Gallery, Wellington, New Zealand); Hayward Annual 1985, Hayward Gallery, London
1986 Brooklyn Museum of Art, New York*; Zwei Landschaften, Galerie Buchmann, Basel*
1987 Hayward Gallery, London*; Marian Goodman Gallery, New York*; Galerie Im Taxispalais, Innsbruck*; Corner house, Manchester*; 'Juxtapositions', The Institute for Art and Urban Resources, Long Island City, New York (with Deacon, Kapoor, Woodrow and others); Documenta, Kassel; 'Current Affairs, British Painting and Sculpture in the 1980s', The Museum of Modern Art, Oxford with The British Council touring to

Hungary, Czechoslovakia and Poland; 'British Sculpture Since 1965', Museum of Contemporary Art, Chicago (travelled to San Fransico Museum of Modern Art; Newport Harbor Art Museum, Newport Beach; The Hirshhorn Museum and Sculpture Garden, Washington D.C.; Albright-Knox Gallery, Buffalo; 'The Analytical Theatre: New Art from Britain' (organised by the Independent Curators Incorporated, New York)
1988 Galeria Foksal, Warszawa*; 'Venice Biennale', British Pavilion, Venice*; Lisson Gallery, London*; Tate Gallery, Liverpool*; Europa Oggi/Europe Now, (organised by The British Council), Museo d'Arte Contemporanea, Prato, Italy
1989 Konrad Fischer, Dusseldorf*; Nishimura Gallery, Tokyo*; Tate Gallery, London*; Stedelijk Van Abbemuseum, Eindhoven*; Kunstsammlung Nordrhein-Westfalen, Dusseldorf*
1990 'Tony Cragg: Sculpture 1975-1990', Newport Harbor Art Museum, Newport Beach, California (travelling to The Corcoran Gallery of Art, Washington; Power Plant, Toronto; Contemporary Arts Museum, Houston)*; 'Culture and Commentary. An Eighties Perspective', Hirshhorn Museum and Sculpture Garden, Washington; Biennale of Sydney, Australia; 'Signs of Life. Process and Materials, 1960-1990', Institute of Contemporary Art, University of Pennsylvania, Philadelphia
1991 'Tony Cragg, recente beelden en Keramiek', Stedelijk Van Abbemuseum, Eindhoven*; La Sculpture Contemporaine, Foundation Daniel Templon, Frejus, France; Objects for the ideal Home, The Legacy of Pop Art, Serpentine Gallery; Que se n'ha fet dels 80?, Fundacio la Caixa, Barcelona
1992 IVAM, Valencia*; 'Tony Cragg, Sculpture', centre for contemporary Arts and Tramway, Glasgow*; Lisson Gallery, London; Carnegie International 1991, The Carnegie Museum of Art, Pittsburgh
1993 British Sculpture from the Arts Council Collection, organised by the Arts Council of Great Britain, Derby Museum and Art Gallery, tour; 'Archimedes Screw', Municipal Museum of Contemporary Art, 's-Hertogenbosch, The Netherlands*.

Selected Public Commissions
1984 Realms and Neighbours, Merian Park, Basel, Switzerland. Commissioned by Kunstmuseum Basel, The Gift of Christoph Merian Collection
1986 Jurassic Landscape, Private Collection Bottmingen, Switzerland, Commisioned by Galerie Buchmann
1987 Fossils The British Oxygen Company, Windlesham, Surrey. Commissioned by The British Oxygen Company Group
1989 Neue Formen. Museum Von der Heydt, Wuppertal, Germany. Commissiosd by Museum Von der Heydt
1993 Archimedes Screw, Corner of Hekellaan and Pettelaarseweg, 's-Hertogenbosch, The Netherlands.

Works in Public Collections
Saatchi Collection, London
Arts Council of Great Britain, London
Musee National d'Art Moderne Georges Pompidou, Paris
Centre Reina Sofia, Madrid
Tate Gallery, London
Weltkunst Foundation London
British Council, London
Union Bank of Switzerland
West Sussex Education Authority, Chichester
Werkstatt Kollerschlag, Vienna
Museum van Hedendaagse Kunst, Gent
Louisiana Museum, Denmark
Kunsthalle, Zurich
Museum Het Kruithuis, 's-Hertogenbosch, Netherlands

Selected Bibliography
S. Vaughan Winter, 'Tony Cragg at Lisson', Artscribe, No.17 April 1979
S. Morgan, 'Tony Cragg', Artforum, October 1980
L. Cooke, 'Tony Cragg at the Whitechapel', Artscribe, March, 1981 No 28
U. Peters, Materialien und Wahrnehmung; ein Zusammenspiel, Von der Heydt Museum, Wuppertal. (exh cat)
M. Newman, Tony Cragg: Vom Konzept zum Symbol, Badischer Kunstverein, Karlsruhe, (exh cat) 1982
Jean-Hubert Martin, Lecons de Choses, Kunsthalle Bern (exh cat) 1982
S. Nairne, N. Serota, F. Crichton, Symbols, Presences and Poetry, Sculpture in the Twentieth Century, Whitechapel Art Gallery, London
D. Brown, Aspects of British Art Today, Metropolitan Art Museum, Tokyo and the British Council (exh cat) 1982
M. Newman, Objects and Figures, Fruitmarket Gallery, Edinburgh, Scottish Arts Council (exh cat) 1983
J. Roberts, 'Urban Renewal', Parachute, No 30, March 1983
L. Cooke, 'Reconsidering the new sculpture', Artscribe, August, 1983
M. Newnam, 'Figuren und Objekte: Neue Skulptur in England', Kunstforum International, June 1983
A. Wildermuth, Tony Cragg, Zwei Landschaften, Buchmann Gallery, St Gallen and de Vleeshal, Middleburg (exh cat) 1984
P. Turner, 'Tony Cragg's Axehead', Tate New Art/ The Artist's View, 1984
R. Kawaguchi, 'Tony Cragg: Photosynthesis by Consciousness', Tony Cragg, Kanransha Gallery, Tokyo, 1984
I. Lemaitre, 'Tony Cragg - You don't know what you are looking at', Artefactum, No 11, November 19985
B. Welter, 'Beeldhouwen met Gruis', Metropolis, No3, 1985

C. Harrison, L. Cooke, <u>A Quiet Revolution, British Sculpture Since 1965</u>, Museum of Contemporary Art, Chicago (exh cat) 1987
M. Newman, <u>The Analytical Thaetre: New Art from Britain</u>, ICI, New York (exh cat) 1987
L. Cooke, 'Tony Cragg: Darkling Light', <u>Parkettv</u>, No 18, 1988
P. Bickers, 'New Models for Old', <u>Art Monthly</u>, September 1988
D. Batchelor, 'Tony Cragg', <u>Artscribe Internationl</u>, May 1989
M. Livingstone (ed), 'British Object Sculptors of the 80s 1', <u>Art Random</u>, Kyoto, Japan
L. Barnes & M. Knode, M. Francis, T. McEvilley, P Schjeldahl, <u>Tony Cragg: Sculptures 1975-1990</u>, Newport Harbour Art Museum (exh cat) 1990
K. Baker, 'All Things Considered', <u>Artforum</u>, March, pp. 105-107, 1991
R. Wollheim, 'Tony Cragg at Forty-one at Newport Beach', <u>Modern Painters</u>, Summer issue, pp.32-37 1991
<u>Tony Cragg, Writings</u>, (1981-1992),Isy Bracot (Editions), Brussels (exh cat)
M. van Rooy, R Steenbergen, <u>Archimedes Screw</u>, Municipal Museum of Contemporary Art, 's-Hertogenbosch, The Netherlands (exh cat) 1993.

Jill Crowley

Born 1946, Cork, Eire
Lives and works in London.
Studied 1966-9 Bristol Polytechnic
1969-72 Royal College of Art.

Selected Exhibitions [*denotes solo exhibition]
1974-77 Ceramic Forms. Crafts Council/British Council Touring Show, Switzerland, Austria, Poland, Sweden, Norway
1976 International Ceramics, received Ravenna Award, Faenza, Italy
1977 Chunichi International Exhibition, Tokyo and Nagoya; Crafts Council Gallery, London*; Figur und Gefass, Hessischen Landesmuseum, Darmstadt
1978 Galerie L. Hamburg, Germany*
1979 Ulster Museum, Douglas Hyde Gallery, Dublin, touring Ireland*; Image and Idea, British Council Tour, Australia and New Zealand; Galerie L. Hamburg, Germany*
1980 The Delighted Eye, a Sense of Ireland, Earlham Street Gallery; Six British Craftsmen of Distinction, Art Latitudes Gallery, New York
1981 Crafts Council Shop, Victoria and Albert Museum, London*
1982 The Maker's Eye, Crafts Council Gallery, London; Oxford Gallery, Oxford*; International Raku and Smoked Clay Exhibition, Uzes, France; Terres, Centre Georges Pompidou, Atelier des Enfants, Paris
1983 Fifty Five Pots, The Orchard Gallery, Londonderry; Designer's Choice, Westminster Gallery, Boston, USA
1984 Self Expressed, Plymouth Art Centre and Spacex Exeter
1985 2nd International Contemporary Arts Fair, Crafts Council Olympia, London; Crafts Council Shop, Victoria and Albert Museum, London*; Aberystwyth Arts Centre, Wales*
1986 Kunstformen Jetzt, Saltzburg; Museum fur Kunst und Gewerbe, Hamburg; 3rd International Contemporary Arts Fair, BCC Olympia, London
1987 The Human Touch, Institute of Contemporary Art, London
1988 Les Printemps des Potiers, Raku workshop and exhibition, Bandol, France; East-West Contemporary Ceramics, British Council, Seoul, and the Fung Ping Shan Museum, Hong Kong; Kapelhuis Gallery, Amersfoort, Holland; Out of Clay, Manchester City Art Gallery
1989 L'Europe des Ceramistes, Auxerre, France, touring; 5th Biennale de Ceramique de Chateauroux, France; Raku Now, Contemporary Ceramics, CPA Gallery, London; Clay Bodies, Contemporary Applied Arts, London; Sea and Shore, Scottish Gallery, Edinburgh
1990 Figurative Works, Bluecoat Display Centre, Liverpool; The Pure Art of the Potter, Drumcroon, Wigan Art Centre; The Decorative Beast, Crafts Council, London
1991 Fourteen British Potters, Il Giardino dell'Arte, Bologna; Cats, Oxford Gallery; Human Interest, Gainsborough's House, Sudbury Suffolk.
1992 Contemporary Applied Arts*
1993 Ceramics, Sculpture and Drawings, Midlands Art Centre, Birmingham*.

Collections
Bellerive Museum, Zurich
International Museum, Faenza
Hess. Landesmuseum, Darmstadt
National Museum, Stockholm
Gothenburg Museum
Perth Museum, Australia
Ulster Museum
Royal Scottish Museum, Glasgow
Victoria and Albert Museum, London
Paisley Museum
Norwich Museum
Bristol City Schools Art Service
Leeds City Museum and Art Gallery
Portsmouth City Museum and Art Gallery
North West Arts
Southern Arts
Cleveland Museum.

Selected Bibliography
C. Reid, <u>Crafts</u> 55, March/April,1982
T.Harrod, <u>Crafts</u> 75, July/August, 1985
P. Johnson,'Sources of Inspiration', <u>Crafts</u> 118, September/October 1992
T. Harrod, 'Our Animal Attitudes', <u>The Spectator</u>, 22/29 December, 1990
A. Britton, Contemporary Applied Arts, 1992
V. Margrie, <u>Studio Pottery</u>, No 2, 1993.

Karen Densham

Born 1960, Lanchester, County Durham, England
Lives and works in London.
Studied 1980-83 Wolverhampton Polytechnic
1985-87 The Royal College of Art
Awarded 1985 prize White Space Open Drawing, London
1987/92 Purchase Prize, Artists in Essex, Epping Forest District Museum
1991 Fletcher Challenge Ceramic Award, New Zealand
1993 London Arts Board Award.

Selected Exhibitions [*denotes solo exhibition]
1983/5 Northern Young Contemporaries, Whitworth Art Gallery, Manchester
1991 Colours of the Earth, British Council Exhibition touring India
1992 Perfect Circles, Plantation House, London*

Selected Bibliography
<u>Colours of The Earth</u>, The British Council, London, 1991
P.Dormer, 'Karen Densham', <u>Crafts</u> 122, May/June 1993.

Ruth Dupré

Born 1954
Lives and works in London.
Studied 1975-76 Ravensbourne College of Art and Design
1976-1980 Hornsey College of Art
1985 Artist in residence, Ailwyn School, Rotherhithe, funded by Marks and Spencer
Visiting lecturer Central St Martin's School of Art, Camberwell; Wimbledon School of Art, London.

Selected Exhibitions [*denotes solo exhibition]
1980 Primavera, Cambridge
1981 Peter Potter, Edinburgh*; Falcon House Gallery, Suffolk*
1982 Henley-on-Thames, Oxfordshire*; Barbican Arts Group exhibition, Barbican Arts Centre, London
1983 Open Eye Gallery, Edinburgh*; Whitechapel Open Exhibition, London
1984 New Ashgate Gallery, Farnham, Surrey*; Anatol Orient, London*
1985 Portfolio Gallery, Atlanta, Georgia*; Westminster Gallery, Boston USA; Oriel Gallery, Belfast*
1986 Aspects Gallery, London; Valentine Show, Crafts Council Shop at the Victoria and Albert Museum; Figurative Show, British Crafts Centre, London
1987 Galerie der Kunsthandwerker, Hamburg, Germany
1988 Bonhams Contemporary Ceramics; Circus comes to Town, touring exhibition, including Sunderland Arts Centre and Livesey Museum, London
1989 Christmas Show at Crafts Council Shop, Victoria and Albert Museum, London
1991 Piers Feetham Gallery, London; Pam Schomberg Gallery, Colchester; Crafts Council Stand, Chelsea Crafts Fair, London
1992 Piers Feetham Gallery, London; Dialogue and Debate, Wimbledon School of Art; Commission for Eurodisney, Paris; Gifts for Valentines, Crafts Council Shop and Victoria and Albert Museum, London.

Collection
Bedford Schools' Collection.

Selected Bibliography
R. Dupré, 'Breaking the Mould', <u>Artists Newsletter</u>, February 1987
R. Dupré, 'Ceramics and Education', <u>Ceramic Review</u> 113, September/October 1988
N. Swengley, Property, <u>The Times</u>, 18 February 1989.

Ken Eastman

Born 1960
Lives and works in Leominster.
Studied 1979-83 Edinburgh College of Art
1984-87 Royal College of Art
1989-93 Visiting Lecturer at Royal College of Art, London,
Lancashire University, Staffordshire University, Edinburgh College of Art, Glasgow School of Art, Loughborough College of Art and Design, Polytechnic of Central London, Harrow College, Camberwell School of Art, Norfolk College of Art and Technology, Wolverhampton University.

Selected Exhibitions [*denotes solo exhibition]
1983 Young Blood, Barbican, London
1987 Paisley Art Institute Exhibition
1989-90 Larger than Life touring exhibition, Plymouth Arts Centre
1990 Jugend Gestaltet International Handwerksmesse, Munich; New British Ceramics, Edinburgh College of Art; British Design Exhibition, Tokyo; Lucie Rie, Hans Coper and their pupils : Sainsbury Centre for Visual Arts, Norwich; Contemporary Applied Arts, London*
1991 The Abstract Vessel, Welsh Arts Council, Cardiff; Beyond the Dovetail, Crafts Council Gallery, London; Aspects of Sculpture, Galerie Marianne Heller, Sandhausen, Germany; Alison Britton and other British Artists : Galerie Kapelhuis, Amersfoort
1992 Leicestershire Schools and Colleges Exhibition; De Witte Voet Gallery, Amsterdam, Frans Hals Museum, Haarlem*; 25th Anniversary Exhibition, Contemporary Applied Arts
1993 Visions of Craft 1972-1993, Crafts Council, London.

Collections
Crafts Council, London
Victoria and Albert Museum, London
Scottish Crafts Collection, Edinburgh
Norwich City Art Gallery
Shipley Museum and Art Gallery, Gateshead
Museum Boymans van Beuningen , Rotterdam, Netherlands.

Selected Bibliography
J Houston, The Abstract Vessel, 1991
R. Zakin, Ceramics : Mastering the Craft, 1991
M. Margetts, International Crafts, Thames and Hudson, London, 1991.
A. Britton, CAA Exhibition leaflet, 1990
T. Harrod, Crafts Magazine 106, September 1990.

Philip Eglin

Born 1959, Gibraltar
Lives and works in Newcastle-under-Lyme.
Studied 1977-79 Harlow Technical College
1979-83 Staffordshire Polytechnic
1983-86 Royal College of Art.

Selected Exhibitions [*denotes solo exhibition]
1986 Figurative Show, Contemporary Applied Arts, London
1986 Summer Show, Contemporary Applied Arts, London
1987 Royal College of Art Exhibition, Japan
1988 Christmas Show, Contemporary Applied Arts, London
1989 Garden Show, Gainsborough's House Gallery, Sudbury; A Summer Picnic, The City Gallery, Leicester; Clay Bodies, Contemporary Applied Arts, London
1990 Stafford Art Gallery, Stafford*; The Decade Ahead, Scottish Gallery, Edinburgh; British Design Exhibition, Tokyo, Japan and Korea; European Commission Exhibition, Avignon, France
1991 Oxford Gallery, Oxford*; The Abstract Vessel, Oriel Gallery, Cardiff; A Staffordshire Tradition, The South Bank Centre, London*; Aspects of Sculpture, Gallerie fur Englische Keramic, Sandhausen, Germany; Favourite Things, Crafts Council Gallery, London; Beyond the Dovetail, Crafts Council Gallery, London; Colours of the Earth, British Council Exhibition touring India
1992 25th Anniversary Show, contemporary Applied Arts, London.

Collections
Brighton and Hove Museum and Art Gallery, Brighton
Victoria and Albert Museum, London
Crafts Council, London
Portsmouth Museum and Art Gallery
Fitzwilliam Museum, Cambridge
Shipley Museum and Art Gallery, Gateshead
Contemporary Arts Society, London.

Selected Bibliography
'British Designers, the New Collectibles', Vogue, 1986
S. Howell, 'The Alpha and Omega', Observer Magazine, London, 29 March 1987
R. Hill, 'The Venus of Harlow New Town', Crafts 102, January/February 1990
T. Harrod, The Independent on Sunday, London, 10 February 1991
J. Norrie, review of Philip Eglin at the Oxford Gallery, Arts Review, 8 March 1991
R. Hill, 'Six of the Best', Crafts 106, September/October 1990
T. Harrod, review of the Abstract Vessel, Crafts 111, July/August 1991
'Short Form', Crafts 112, September/October 1991
T. Harrod, 'Philip Eglin, Beauty of Continuities', Ceramic Review 131, September/October, 1991
A. Britton, 'Philip Eglin: A Staffordshire Tradition?', The South Bank Centre, London
'Short Form', Crafts 118, September/October, 1992.
J. Houston, 'Philip Eglin', Studio Potter 1993

Elizabeth Fritsch

Born 1940, Wales
Lives and works in London.
Studied 1958-64 Birmingham School of Music and Royal Academy of Music, London
1968-71 Royal College of Art (ceramics)
1970 MA (RCA), Silver Medal (RCA), for ceramics, Herbert Read Memorial Prize.

Selected Exhibitions [*denotes solo exhibition]
1971-72 Bing and Grondahl Porcelain, Copenhagen*
1973 Towards Ceramic Sculpture, Oxford Gallery
1974 Crafts Council, London*; Ceramic Forms, British Council, touring to Europe
1976 Improvisations : Earth to Air, British Crafts Centre, London*; Gold Medal, International Ceramics Competition, Sopot, Poland; British Ceramics, Pennsylvania State University
1977 Silver Jubilee Exhibition, Victoria and Albert Museum, London; British Council touring Exhibition to the Middle East
1978 Pots about Music, Temple Newsam House, (Leeds City Art Galleries), touring to Glasgow, Bristol, Bolton and Gateshead*
1979 Pots about Music, Victoria and Albert Museum, London*
1984 Pots from Nowhere (fictional archaeology), Royal College of Art, London*
1985 Fast Forward, Institute of Contemporary Arts, London and touring
1986 solo room in British Art and Design, Kunstlerhaus, Vienna; Nine Potters, Fischer Fine Art, London
1987 Bernard Leach Centenary Post Office Stamp issue with Hans Coper and Lucie Rie, leading to The Stamp of Fame, Fischer Fine Art, London; London-Amsterdam : New Art Objects, Crafts Council touring to Amsterdam
1988-89 British Council touring exhibition, Tokyo and Kyoto
1989 L'Europe Des Ceramistes, European touring exhibition Galerie Besson, London*
1990 Cross Rhythms and Counterpoint, Royal Museum of Scotland, Edinburgh*; Judged Fletcher Challenge International Ceramics Competition, Auckland, New Zealand
1990-91 Retrospective, Hetjens Museum, Dusseldorf*
1991 British Ceramics Exhibition, Bellas Artes, New York; The Abstract Vessel, Oriel Gallery, Cardiff; Europaisches Kunst Handwerk Stuttgart
1992 La Fabbrica Estetica, Alessi, Italy; Colours of the Earth, British Council Exhibition touring India; Keramiske Veje, Den Frie Gallery, Copenhagen
1992-3 Retrospective, Pilscheur Fine Art, London*
1993-5 Vessels from another World, Northern Centre for Contemporary Art, Sunderland and touring*.

Collections
Crafts Council, London
Victoria and Albert Museum, London
City Art Gallery, Bristol
Leeds City Art Gallery
City Art Gallery, Manchester
Dansk Kunstindustrie, Copenhagen
Museum Boymans van Beuningen , Rotterdam.

Selected Bibliography
J. Houston, 'Traps to Fill Emptiness', Crafts 10, September/October 1974
E. Lucie Smith, The World of the Makers, Paddington Press 1975
E. Fritsch, 'Pots from Nowhere', Crafts 71, November/December 1984
P. Dormer and D. Cripps, Elizabeth Fritsch in Studio, Bellew Publishing, 1986
C. Frankel, 'Clay in their Hands', Illustrated London News, November 1986
C. Courtney, 'Post Modern', Crafts 88, September/October 1987
'Pot Reports', Ceramic review 107, September/October 1987
E. Fritsch, 'Notes on Time', Crafts 97, March/April 1989
G. Hughes, Review of Elizabeth Fritsch, Galerie Besson, Arts Review, 20 October 1989
'Short Form', Crafts 106, September/October 1990
R. Hill, 'Workshop of the World', Crafts 108, January/February 1991
'Colourful Clay', 'Short Form', Crafts 109, March/April 1991
T. Harrod, review of The Abstract Vessel, Crafts 111, July/August 1991.

Antony Gormley

Born 1950, London
Lives and works in London.

Selected Exhibitions [*denotes solo exhibition]
1980 Nuove Imagine, Milan, Italy
1981 British Sculpture in the Twentieth Century, Whitechapel Art Gallery, London; Objects and Sculpture, Institute of Contemporary Art, London and Arnolfini, Bristol
1982 Figures and Objects, John Hansard Gallery, London; Objects and Figures, Fruitmarket Gallery, Edinburgh; Hayward Annual : British Drawing, Hayward Gallery, London; Aperto '82, Biennale de Venezia, Venice
1983 New Art, Tate Gallery, London; The Sculpture Show, Hayward and Serpentine Galleries, London
1983/4 Transformations : New Sculpture from Britain, XVII Bienal de Sao Paulo, Museu de Arte Moderna, Rio de Janiero, Museo de Arte Moderno, Mexico, Fundacao Calouste Gulbenkian, Lisbon

1984 Antony Gormley, Salvatore Ala Gallery, Milan/New York*; An International Survey of Recent Painting and Sculpture, the Museum of Modern Art, New York; Anniottanta, organized by the Galleria Communale d'Arte Moderna, Bologna (Bibioteca Communale Classense, Ravenna section)

1985 Antony Gormley, Stadtische Galerie Regensburg, Frankfurt*; Antony Gormley Drawings, Salvatore Ala Gallery, Milan/New York*; Walking and Falling, Plymouth Arts Centre, Plymouth, Kettle's Yard, Cambridge and Interim Art, London; Nuove trame dell'Arte, Castello Colonna di Genazzano, Italy; The British Art Show, Birmingham, Sheffield, Edinburgh, Southampton; Metaphor and/or symbol, National Gallery of Modern Art, Tokyo, National Museum of Art, Osaka; Three British Sculptors,Neuburger Museum, State University of New York, Purchase

1986 Art and Alchemy, Venice Biennale, Italy; Prospect '86, Frankfurter Kunstverein, Frankfurt; Between Object and Image, Ministerio de Cultura and the British Council, Palacio de Velasquez, Parque del Retiro, Madrid, Barcelona and Bilbao; Vom Zeichnen : Aspekte der Zeichnung, Frankfurter Kunstverein, Kassele Kunstverein, Museum Moderner Kunst, Vienna

1987 Antony Gormley, Five Works, Serpentine Gallery, Arts Council of Great Britain, London*; The Seibu Department Stores, Tokyo*; Mitographie : Luoghi Visibili/Invisibile dell'Arte, Pinacoteca Comunale, Ravenna; Documenta 8, Kassel, Germany; Avant-Garde in the Eighties, Los Angeles County Museum of Art, Los Angeles; TSWA 3D, City Walls, Derry, Ireland; The Reemergent Figure, Seven Sculptures at Storm King Art Centre, Mountainville, New York; State of the Art, Institute of Contemporary Art, London and touring; Chaos and Order in the South, University Psychiatric Clinic, Mainz, Germany

1987/88 Viewpoint, musees Royaux des Beaux-Arts de Belgique, Brussels

1988 Contemporary Sculpture Centre, Tokyo, Japan*; The Impossible Self, Winnipeg Art Gallery and Vancouver Art Gallery; Made to Measure, Kettle's Yard, Cambridge; Starlit Waters : British Sculpture and International Art 1968-88, Tate Gallery, Liverpool; ROSC '88, Dublin, Ireland

1988/89 British Now : Sculpture et autres Dessins, Musee D'Art Contemporain de Montreal, Montreal

1989 Louisiana Museum of Modern Art, Humlebaek, Denmark*; It's a Still Life, Arts Council Collection, The South Bank Centre, London; Corps-Figures, Artcurial, Paris; Visualization on Paper : drawing as a preliminary medium, Germans Van Eck, New York

1990 Great Britain – USSR, The House of the Artist, Kiev/The Central House of the Artist, Moscow; British Art Now : A Subjective View, British Council Show, touring Japan; Made of Stone, Galerie Isy Brachot, Brussels

1991 Antony Gormley : Field and Other Figures, Modern Art Museum, Fort Worth*; Sculpture for the old Jail, Charleston/places with a past, Spoleto Festival USA, Charleston; Inheritance and Transformation, The Irish Museum of Modern Art, Dublin; Colours of the Earth, British Council Exhibition touring India

1992 Antony Gormley : Learning to See : Body and Soul, Contemporary Sculpture Centre, Tokyo*; Drawing Show, Frith Street Gallery, London; C'est pas le fin du monde, La Criee, Rennes/Faux Mouvement, Meta/FRAC Basse Normandie, Caen/FRAC Poitou Charentes, Angouleme; Arte Amazonas, Museu de Arte Moderna, Rio de Janiero, Brazil 1992/1993 Staatliche Kunsthalle, Berlin;

1993 Sculpture in the Close, Jesus College, Cambridge; Natural Order, Tate Gallery, Liverpool; Images of Man, Isetan Museum of Art, Tokyo/Daimura Museum, Umeda-Osaka/Hiroshima City Museum of Contemporary Art; Des Dessins pour les eleves du centre des Deux Thielles, Le Landeron, Centre scholaire et sportif des Deux Thielles, Le Landeron/Offentliche Kunstsammlung Basel, Museum fur Gegenwartskunst, Basel.

Collections
Tate Gallery, London
Victoria and Albert Museum, London
Contemporary Arts Society
Southampton City Art Gallery
Louisiana Museum, Humlebaek
Moderna Museet, Stockholm
Malmo Konsthalle, Sweden
Art Gallery of New South Wales, Sydney
Stadt Kassel
Leeds City Art Gallery
Sapporo Sculpture Park, Hokkaido
Walker Arts Centre, Minneapolis
Fort Worth Museum of Modern Art, Texas
Marquiles Foundation, Florida
Henry Moore Foundation for the study of Sculpture
The Irish Museum of Modern Art, Dublin
The Scottish National Gallery of Modern Art, Edinburgh
Villes de Rennes, France
British Council
Arts Council of Great Britain.

Selected Bibliography
'Nuove Immagine', Flash Art, Summer Issue, 1980
L. Cooke, 'Antony Gormley, Whitechapel Gallery', Artforum, Summer 1981
E. Pascal, 'Tongue and Groove', Art Monthly, May 1983
N. Dimitrijevic, 'Antony Gormley', Flash Art, January 1984
N. Serota, 'Transformations – New Sculpture from Britain', Arte Factum, February/March 1984
K. Levin, 'The Clone Zone', The Village Voice, May 15, 1984

B. Biegler, 'Antony Gormley at Salvatore Ala', The East Village Eye, June 1984
S. Miller, 'Antony Gormley Riverside Studios', Art Press, December 1984
W. Packer, 'Body building exercises the artist's mind', Financial Times, London, September 25 1984
W. Feaver, 'Variations on a Body', The Observer, London, September 1984
M. Vaisey, 'Art and Counterpart', The Sunday Times, London, September 16 1984
S Miller, 'Antony Gormley at Riverside', Artscribe no 49, 1984
W. Januszczak, 'Going up like a Lead Balloon', The Guardian, London, October 2 1984
P. Kopecek, 'Antony Gormley', Art Monthly, October 1984
K. Linker, 'Antony Gormley', Artforum, October 1984
F. Ted Castle, 'Antony Gormley at Salvatore Ala', Art in America, October 1984
M. Archer, 'Anthony Gormley', Flash Art, December 1984
N. Dimitrijevic, 'La Sculpture apres l'evolution', Flash Art no 6, January 1985
A. Gormley, Flash Art Gallerie no 21, March 1985
H. Weskott, 'Antony Gormley', Kunst Forum, 1985
D. Wright, 'Beyond Appearances', Arts Review, June 1985
R. Barilli, 'Eccentrici insulari', L'Espresso no 25, June 1985
'Monumentale Body-art', Passauer Neue Presse, July 1985
'Frankfurt zeigt zwei Skulptur-Ausstellungen', Giess Anz. Giessen, August 14 1985
'Figuren in Fadenkreuz', ART das Kunstmagazine, September 1985
'Bleierner Gast im Steinernen Haus', Frankfurter NeuePresse, August 13 1985
'Antony Gormley', Frankfurter Allgemeine Zeitung, 17 August 1985
G.L. Bastos, 'Antony Gormley, a case', Neue Kunst in Europe no 9, 1985
R. Pokorny, 'Using the Body as if it was a Face', Neue Kunst in Europe no 9, 1985
M. Weinstein, 'Antony Gormley', Westuff no 2, September 1985
P. Bickers, 'When is sculpture not a Sculpture', Aspects no 29, 1985
V. Conti, 'Antony Gormley', Artefactum, September/October 1985
J. Higgins, 'Antony Gormley', ARTnews, New York, December 1985
G. Dorfles, 'Antony Gormley', Italian Vogue, February/March 1986
Zaya, 'Antony Gormley : El Otro de uno Mismo', Culturas Diaro 16, 1986
A. Graham-Dixon, 'Antony Gormley's Bizarre Sculptural Techniques', Harpers/Queen, London, February 1987
R. Cork, 'Figures of Everyman', The Listener, London, March 19 1987
K. Levin, Village Voice, May 20-26 1987
W. M. Faust, 'Documenta Special', Wolkenkrazer Art, Summer 1987
M. Brenson, 'Images that Express Essential Human emotions', The New York Times, July 1987
W. Zimmer, 'Figurative Sculpture Makes Impact at Storm King Art Centre', New York Times, August 1987
M. Archer, 'State of the Art', Artforum, New York, Summer 1987
M. Roustayi, 'An Interview with Antony Gormley', Arts Magazine, New York, September 1987
M. Gooding, 'Great Britain : TSWA 3D', Flash Art, Milan, October 1987
J. Higgins, 'Britain's New Generation', Art News, New York, December 1987
J.P. Lemee, 'Antony Gormley man made man', Art Presse 119, 1988
S. J. Checkland, 'And the Word was made Art', The Times, London, April 2 1988
J. Bakewell, 'Vote to cement history', The Sunday Times, October 30 1988
Brickman, The Sunday Telegraph, November 13 1988
W. Januszczak, 'The Might Have been Man', Weekend Guardian, London, December 17 1988
M. Wachtmeister, Sysvenenska Dagbladet, Malmo, Sweden, January 30 1989
G. K. Sutton, 'The Brick Man moves on again', The Sunday Times, London, April 9 1989
S.Morley, 'Antony Gormley', Tema Celeste, Siracusa, April/June 1989
M. Brenson, 'A Sculptor who really gets into his work', New York Times, May 7 1989
A. Graham-Dixon, 'Life set upon a Cast', The Independent, London, May 9 1989
Antony Gormley, Art and Design vol 5 no 3/4, London, 1989
C. Turnbull, 'Antony Gormley : The Impossible Self', The Green Book, vol 111 no 1, Bristol, 1989
V. Lynn, 'Earth above Ground', Art and Text, Paddington NSW Australia, Summer 1990
D. Pagel, 'Antony Gormley', Arts Magazine, New York April, 1990
New Art, Harry H. Abrams INC, New York, 1990
M. Brenson, 'Antony Gormley : Salvatore Ala Gallery', Weekend, The New York Times, 29 March 1991
M. Brenson, 'Visual Arts join Spolets Festival USA', New York Times, 27 May 1991
B. Schabsky, 'Antony Gormley', Arts Magazine, New York, Summer 1991
J. Hart, 'Interview with Antony Gormley', Journal of Contemporary Art, vol 4, no 3, New York, Fall 1991
J. Tyson, 'Gormley's <field> of figures magically moving', Fort Worth Star-Telegram, Fort Worth, Texas, 15 October 1991
R. Taplin, 'Antony Gormley at Salvatore Ala', Art in America, New York, November 1991
D. Pagel, 'Gormley's sculptures get physical', Los Angeles Times, 8 October 1992
C. Casorati, 'Emozioni di piombo', Avvenire, Rome, 15 December 1992
E. Gallian, 'I contenitori dell'ignoto', L'Unita, Rome, 26 December 1992
A. Tager, 'Reviews : Los Angeles: Antony Gormley', ARTnews, New York, January 1993
T. Grimley, 'Monument to a proud past', The Birmingham Post and Mail, 1 March 1993.

Susan Halls

Born 1966, Kent
Lives and works in London.
Studied 1984-86 Medway College of Art and Design
1986-1988 Medway college of Art and Design
1988-90 Royal College of Art, MA Ceramics
Awarded 1989 First prize in Campbell's Soup Tureen Design Project
1990 Scholarship to study at the Banff Centre for the Arts, Alberta, Canada
Teaches at the Kent Institute of Art and Design, Rochester,
Wolverhampton University, Manchester University, Jacob Cramer School of Art, Leeds.

Selected Exhibitions [*denotes solo exhibition]
1989 and annually Mall Galleries London, Society of Wildlife Artists
1990 JAL Image and Object, touring exhibition, Japan, Kyoto, Nagoya, Tokyo; The Decorative Beast, Crafts Council, London
1991 Beyond the Dovetail, Crafts Council, London
1992 Colours of the Earth, British council Exhibition touring India; Paintings, Drawings and Ceramics, Andrew Usiskin Contemporary Art, London*
1993 Ceramic Contemporaries, Victoria and Albert Museum, London; Beastly things, Devon Guild of Craftsmen; Walking the Dog, South Bank Craft Centre; Ceramic Showcase at Aberystwyth Arts Centre.

Collections
Banff Centre for the Arts, Alberta, Canada
County Hall, Maidstone, Kent
Clonter Opera Farm, Cheshire
Campbell Museum, Philadelphia.

Selected Bibliography.
P. Dormer (ed), The Decorative Beast, October 1990
P. Johnson, review of Paintings, Drawings and Ceramics, Usiskin Gallery, Crafts, January/February 1993
R. Thomas, 'Antennae', World of Interiors, April 1993.

Gwyn Hanssen Pigott

Born 1935, Ballarat, Australia
Lives and works in Australia.
Studied University of Melbourne, Australia
With Ivan McMeekin, Sturt Pottery, Mittagong, New South Wales
Awards include 1980 Mayfair Ceramic Award, Meat Market Crafts Centre, Melbourne
1982 Gold Coast Ceramic Award, Queensland, City of Brisbane Craft Award, Brisbane
1983 North Queensland Ceramics Award, Townsville
1984 Fletcher Brownbuilt Pottery Award, Auckland, Darling Downs First National Ceramic Award, Toowoomba
1991 Eleventh National Craft Award, Darwin.

Selected Exhibitions [*denotes solo exhibition]
1961 Primavera, London*
1963 Primavera, London*
1965 Primavera, London*
1970 British Potters,Molton Gallery, London
1971 Crafts Centre, London*
1972 Galerie des Deux Tisserands, Paris*; International Academy of Ceramics, Vallauris
1972-3 Ten British Potters, Crafts Council, German tour
1973 The Craftsman's Art, Victoria and Albert Museum, London
1976 Contemporary Pottery from Henry Rothschild's Collection, Bristol, Newcastle, Bradford
1978 Arts Victoria 78, Meat Market Crafts Centre, Melbourne
1981 The Potter's Art, Touring tableware exhibition; Gwyn Pigott and John Pigott, Jam Factory Gallery, South Australia; Australian Crafts, Meat Market Gallery, Melbourne
1982 Australian Ceramics, The Potters Gallery, Brisbane
1983 Blackfriars Gallery, Sydney*; Victor Mace Fine Art, Brisbane*
1984 Casson Gallery, London*; Australian Crafts, Meat Market Gallery, Melbourne; Profile of Presence, Narek Gallery, Canberra
1985 Potters Gallery, Sydney*; Clay and Porcelain, Distelfink Gallery, Melbourne; A Collection in the Making, Crafts Council, London; Sturt Potters, New South Wales Government Exhibition, Tokyo
1986 Distelfink Gallery, Melbourne*; Victor Mace Fine Art, Brisbane*; Ceramics Expo, Ballarat Fine Art Gallery; Woodfire, Latrobe Valley Arts Centre, Gippsland
1987 Handmark Gallery, Hobart*; Garry Anderson Gallery, Sydney*; Leach Tradition, Pro-Art Gallery, St Louis; Maker's Choice, Jam Factory Gallery, Adelaide
1988 Jam Factory Gallery, Adelaide*; Canadian/Australian Exchange, Calgary; Michael Casson and Gwyn Hanssen Pigott, Devise Arts, Melbourne; A Complementary Caste : A Homage to Women Artists in Queensland, Centre Gallery, Gold Coast; Australian Decorative Arts 1985-88, Australian National Gallery, Canberra
1989 Fremantle Art Centre*; Garry Anderson Gallery, Sydney*; Out of the North, Perc Tucker Art Gallery, Townsville; The Harrow Connection : Studio pottery 1963-8, Crafts Council, London
1990 Margaret Francey Gallery, Brisbane*; Narek Gallery, Canberra*; Garry Anderson Gallery, Sydney*; Homage to Morandi, Garry Anderson Gallery, Sydney
1991 Pro-Art Gallery, St Louis*; Margaret Francey Gallery, Brisbane*; Narek Gallery, Canberra*; Une Passion pour la Ceramique : la Collection Fina Gomez, Musee des Artes decoratifs, Paris; Brindley Collection-Ceramics from the 80s, Crossman Gallery, University of Winsconsin, Whitewater
1992 Le Bol aux Quatre Coins de la terre, Galerie Leonelli, Lausanne; Ceramic Still Life, Garth Clark Gallery, New York;
Australia-New Design Visions, 2nd International Crafts Triennial, Art Gallery of Western Australia, Perth; Cinafe Exhibition, Narek Gallery, Chicago; Galerie Besson, London*
1993 Crafthouse Gallery, CCBC, Vancouver, Canada*, PRO-ART Gallery, St Louis, USA*, Garth Clark Gallery, New York, USA*.

Collections
Art Gallery of South Australia, Adelaide
City Fine Art Gallery, Ballarat
Holbourne Museum and Crafts Study Centre, Bath
Ulster Museum, Belfast
Civic Art Gallery and Museum, Brisbane
Queensland Art Gallery, Brisbane
Bristol Art Gallery
Australian National Gallery, Canberra
Parliament House, Canberra
Fremantle Arts Centre
Tasmanian Museum and Art Gallery, Hobart
Queen Victoria Museum and Art Gallery, Launceston
Crafts Council of Great Britain, London
Victoria and Albert Museum, London
City Art Gallery, Manchester
National Gallery of Victoria, Melbourne
Paisley Museum and Art Gallery
Art Gallery of Western Australia, Perth
Musee National de Ceramique, Sevres
Perc Tucker Regional Art Gallery, Townsville.

Selected Bibliography
M. Casson, 'Potttery in Britain Today', Fleish, 1967
P.Lane, Studio Pottery, Collins, London, 1983
V. Margrie, 'Influence and Innovation', Ceramic Review, July/August, 1986
J. Shaw, 'Integrity of Function', Craft Arts, June/August, 1987
M. Margetts (Ed.), 'Sun, Surf and Ceramics', Special Report: Australia, Crafts 85, March/April 1987
P. Rice and C. Gowing, British Studio Ceramics in the 20th Century, Barrie and Jenkins, 1989
O. Watson, British Studio Pottery, The Victoria and Albert Museum Collection, Phaidon/Christies, London, 1990
G. Cochrane, The Crafts Movement in Australia: A History, University of NSW Press, 1992
M. Margetts (Ed.), International Crafts, Thames and Hudson, 1991

Ewen Henderson

Born 1934, Staffordshire
Lives and works in London.
Studied 1964 Pre-Diploma course at Goldsmith's College
1965-8 Camberwell School of Art.

Selected Exhibitions [*denotes solo exhibition]
1970 Primavera, London
1973 Craftsman's Art, Victoria and Albert Museum, London
1975/6 Marjorie Parr Gallery, London*
1976 Atmosphere Gallery, Zurich, Switzerland
1977 Dr. Paul Koster Gallery, Germany
1978 Faenza international Exhibition, Italy
1979 Kettle's Yard, Cambridge
1981 Somers Gallery, Heidelberg, Germany; Amalgam Gallery, Barnes, London
1983 Charlotte Hennig Gallery, Darmstadt, Germany; Solomon Gallery, Dublin, Ireland
1984 Eight Ceramicists, British Crafts Centre, London; Maya Behn Gallery, Zurich, Switzerland
1985 Fitzwilliam Museum, Cambridge
1986 Retrospective Exhibition, British Crafts Centre, London*; Rituals of tea, Garth Clark, London; Nine Potters, Fischer Fine Art Gallery, London;
1987 Eight British Ceramicists, Garth Clark, San Francisco, USA; New Art Forms, Garth Clark, Chicago; Galerie De Vier Linden, Holland
1988 Galerie Besson, London*; East-West ceramics, British Council, Seoul; Sotheby's Prize exhibition, London/Tokyo; Marianne Heller Gallery, Heidelberg
1988-89 Contemporary British Crafts, British Council, Kyoto/Tokyo
1989 National Museum, Stockholm*; Galerie Handwerk, Munich, Germany; L'Europe des Ceramistes, Auxerre, France, touring to Madrid, Linz, Budapest, Strasbourg and Campagne Ardennes
1990 Garth Clark Gallery, New York*
1991 Ouwehand Collection, Bellerive Museum, Zurich;

Configura 1, Erfurt; First Shigaraki International Exhibition, Shigaraki Ceramic Cultural Park, Japan; British Ceramics (curated by Tony Hepburn), Belles Artes Gallery, Santa Fe/ New York; British Ceramics, Gallery Il Giardino dell'Arte, Bologna; Aspects of Sculpture, Marianne Heller Gallery, Sandhausen and Munich
1991/2 Colours of the Earth, British Council Exhibition touring India
1992 British and Dutch Ceramics, Rufford Craft Centre, England; William Mills (painting) and Ewen Henderson (ceramics), Alpha House Gallery, Dorset; Summer Exhibition, William Jackson Gallery, London; Inaugural Exhibition, European Ceramic Workcentre, Den Bosch, Netherlands; Four elements; Three Nations – Modern Ceramics of Germany, England and Japan : Collection of Dr. G. Freudenberg, Museum fur Kunsthandwerk, Frankfurt
1992 International Invitational Exhibition of ceramic art, National Museum of History, Taipei, Taiwan
1993 Galerie Heller, Sandhausen*.

Collections
Art Gallery of South Australia, Adelaide
Stedelijk Museum, Amsterdam
Ulster Museum, Belfast
Australian National Gallery, Canberra
National Museum of Wales, Cardiff
Kyoto Museum of Modern Art, Kyoto
Crafts Advisory Council permanent collection
Victoria and Albert Museum, London
Los Angeles County Museum
Museum Boymans van Beuningen , Rotterdam
The Shigaraki Ceramic Cultural Park, Japan
Wuerttembergisches Landesmuseum, Stuttgart
The Museum of Modern Art, Tokyo
Winnipeg Art Gallery, Winnipeg.

Selected Bibliography
O. Watson, British Studio Pottery : The Victoria and Albert Museum Collection, Phaidon/Christies, London, 1990
C. Reid, 'Henderson Territory', Crafts, January/February 1981
J. Tesser, 'Ceramic Dream of Shigaraki', Ceramic Art and Perception No 6, Australia, 1991
G. Smith, review of Inaugural exhibition at 's-Hertogenbosch, Economist, London, August 1992
E. Langendijk, Keramik Magazine, August 1992
D. Whiting, Neue keramik, Berlin, January/February 1993.

Tracey Heyes

Born 1964
Lives and works in Sheffield.
Studied 1983-86 Lanchester Polytechnic, Coventry, Painting and Ceramics
1987-88 South Glamorgan Institute of Higher Education, Cardiff, MA Ceramics
1987 Wolverhampton Polytechnic, Lecturer
1988-89 Freelance Prop-maker
1989-90 Yorkshire and Humberside Association for Further and Higher Education
1989 Part time ceramics tutor at Rotherham Arts Centre and Rockingham College, Bath, teaching adult and special needs groups
1990-92 Member of Unlimited Combined Arts Team working on short residencies in schools
1990-Dec1991 Ceramist in residence, Artskill Alternative to Drugs Project, Kirkby, Merseyside, teaching ceramics and life drawing
1992 Awarded Churchill Travel Fellowship, Canada;Freelance Community Artist, project work with schools as part of Sheffield's Link with Industry scheme
Part-time Lecturer (Ceramics), 18+ Foundation, Art and Design, Doncaster; Red Deer College, Alberta, Canada Summer Programmes, Raku and Tile Making; Part-time Lecturer (Drawing), Thomas Rotherham Sixth Form College; Design and Making of Community mural with community group at New Parks Community College, Leicester
1993 Ceramic Mural commission, Rotherham Indoor Market.

Selected Exhibitions [*denotes solo exhibition]
1985 Group exhibition, Whitefriars Gallery, Coventry
1986 Leicestershire Arts, Loughborough
1990 Group exhibition, Zutphen, Holland; Ceramics and Glass, Holmfirth Art Gallery, Dunford; Portals Gallery, Chicago
1991 Exhibited with Portals Gallery at The International Arts Fair, Chicago
1992 New Clay Sculpture, M Michaelson, London*; Exhibited in the Crafts Council Shop at the Victoria and Albert Museum
1993 Art '93 Business Design Centre, London; Ceramic Sculpture, Leicester City Art Gallery*; All Around the Home, Drumcroon Arts Centre, Wigan.

Selected Bibliography
J. Simmons, The Independent Art Magazine Monthly, 1992.

Jefford Horrigan

Born 1955
Lives and works in London.
Studied 1973-5 Epsom School of Art
1975-8 Goldsmiths college of Art.

Selected Exhibitions [*denotes solo exhibition]
1978/9 New Contemporaries, Institute of Contemporary Arts, London
1981 Institute of Contemporary Art, London*
1982-8 Whitechapel Open, Whitechapel Art Gallery, London
1983 Tom Allen Centre, London*; Young Blood, Riverside Studios, London; Painting and Sculpture, Aspex Gallery, Portsmouth; Views and Horizons : International Sculpture Symposium, Yorkshire Sculpture Park, Wakefield; The Face, Monika Kinley Art House, London
1984 People and Place, St. Botoph's Church, Aldgate and Hackney Hospital, London; Tony Bevan / Jefford Horrigan / Glenys Johnson / Jan Wandja, Bluecoat Gallery, Liverpool
1985 Hands, Anne Berthoud Gallery, London; Hand Signals, Ikon Gallery, Birmingham (toured to Chapter Gallery, Cardiff, Milton Keynes Exhibition Gallery, Milton Keynes, and City Museum and Art Gallery, Peterborough)
1987 Conversations, Arts Council Touring Show
1988 Out of Clay, Manchester City Art Gallery
1989 Adam Gallery, London*; Acava Central Space Gallery, London*; Electrographies, Hardware Gallery, London
1990 A New Necessity – First Tyne International Exhibition of Contemporary Art, Gateshead
1991 Architectural Association, London*; Un'Estate Inglese, Palazzo Ruini, Reggio Emilla, Italy
1992 Whitechapel Open, Whitechapel Art Gallery, London; Body as a Room, Ruskin School of Drawing, Oxford
1993 The Ruskin School of Drawing, Oxford*.

Bryan Illsley

Born 1937, Surbiton, Surrey
Lives and works in London.

Selected Exhibitions [*denotes solo exhibition]
1976 Penwith Gallery, St Ives (Retrospective of wooden objects)
1981 The Maker's Eye, British Craft Council, London
1984 British Craft Council, London*
1988 Contemporary Applied Arts, London*; Contemporary British Crafts, British Council*
1989 Common Ground – Out of the Wood, British Craft Council, London; Clay Bodies, Contemporary Applied Arts, London
1990 Jamison-Thomas Gallery, Portland, Oregon*; Chiltern Sculpture Trail, Oxford Residency*; Gallerija Ars Ljubljana, Slovenia
1991 London International Art Fair; Chicago International Art Fair; Jamison-Thomas Gallery, Portland Oregon*; Electrum Gallery Anniversary Show
1992 Brewery Arts, Cirencester*; Jamison-Thomas Gallery, Portland, Oregon.

Collections
Contemporary Art Society, London
Kettle's Yard, Cambridge
Plymouth City Art Gallery
Camden, Cornwall, Devon and Reading Education committees
Arts Council of Great Britain
Portsmouth City Museum
Museum of Modern Art, Kyoto
Crafts Council of Great Britain, London
Victoria and Albert Museum, London
Smart Museum, University of Chicago.

Selected bibliography
C. Reid, Crafts Council, 1984
E. Lucie-Smith, Sculpture Since 1945, Phaidon, 1987
A. Britton, Sources for St Ives, Contemporary Applied Arts, 1988

Pamela Leung

Born 1962, Hong Kong
Lives and works in London.
Studied 1981-84 Middlesex Polytechnic, 3 Dimensional Design, BA (Hons)
1984-5 Goldsmiths College, University of London, Diploma in Ceramics
1989 Visiting Lecturer at Polytechnic of South West
1990 Lecturer at Llantarnam Grange Arts Centre, Cwmbran; Part-time tutor at Camden Institute
1991 Lecturer at Lancaster University
1993 Part-time tutor at Kingsway Camden College.

Selected Exhibitions [*denotes solo exhibition]
1987 Arts and Crafts Movement, London*; Anatol Orient, London*
1987 The New Spirits, Crafts Council, London
1988 The New Spirit, The Craft and Folk Art Museum, Los Angeles
1989 Oxford Gallery, Oxford*; Larger Than Life, Plymouth Art Centre; Jugend
Gestaltet 89, Munich
1990 Michaelson and Orient, London*; Chinese Arts and Crafts Exhibition 1990,
Lancashire County Council; Diverse Cultures, Crafts Council; National Garden Festival,
Gateshead; Edinburgh Festival Ceramics Exhibition, Edinburgh College of Art
1991 Usher Gallery, Lincoln*; The Avant Garden, Barbican Centre, London
1992 Model House, Mid Glamorgan*; Hering and Lehmann Keramikgalerie, Berlin*;
The Hannah Peschar Gallery Summer Show; Hauptsache Keramic !, Hamburg
1993 Rufford Craft Centre; Hering and Lehmann Keramikgalerie, Berlin.

Collections
1987 Leicestershire Art Collection
1988 Contemporary Art Society
1991 Milton Keynes Community Trust
1991 Lincolnshire County Council
Also work in private collections in Munich, Los Angeles, New Zealand.

Gillian Lowndes

Born 1936, Cheshire
Lives and works in Essex.
Studied 1957-59 Central School of Art, London
1960 Paris
1971-72 Spent two years in Nigeria
1975-92 Part time teaching at Camberwell School of Art and Design, Central St.
Martins, London.

Selected Exhibitions [*denotes solo exhibition]
1980-81 Image and Idea, British Council touring, New Zealand and Australia
1981 British Ceramics and Textiles, Knokke Heist, Belgium
1983 Crafts Council Shop, Victoria and Albert Museum*
1984 Eight Ceramists, British Crafts Centre; British Ceramics, British Council touring,
Czechoslovakia
1985 Three from Camberwell Amalgam, London
1986 European Ceramics, Fitzwilliam Museum, Cambridge
1987 Gillian Lowndes, New Ceramic Sculpture, Crafts Council Retrospective*
1988 Chicago Arts Fair; London, Amsterdam, New Art objects from Britain and
Holland; East-West Contemporary Ceramics, Seoul, British Council
1989 Crafts Classics, Crafts Council, London
1990 The Harrow Connection, Crafts Council
1991 The Decorative Beast, Crafts Council;
English Ceramics, Aspects of Sculpture, Sandhausen and Munich; British Ceramics
Now, Santa Fe and New York, Bellas Artes Gallery; Colours of the Earth, British
Council touring India and Malaysia; Beyond the Dovetail, Crafts Council, London
1992 20th Anniversary of the visiting Artist Programm Exhibition, University of
Colorado; A Difficult Tradition, Royal Festival Hall, London; International Invitational
Exhibition of Ceramic Art, Taipei, Taiwan
1993 Visions of Craft, Crafts Council Collection, London.

Collections
Victoria and Albert Museum, London
Paisley Museum
Cleveland Collection
Ulster Museum
Landesmuseum, Stuttgart, Germany.

Selected Bibliography
T. Birks, 'The Art of the Modern Potter', Country Life, 1979
A. Suttie, 'The Dangerous Edge of Things', Crafts 75, 1985
T. Harrod, 'Transcending Clay', Crafts 84, 1987
H. Pim, 'Uncertain Echoes', Ceramic Review 103, 1987
M. Garlake, Art Monthly, 1987
T. Harrod, Gillian Lowndes: New Ceramic Sculpture, Crafts Council, London, 1987

Bruce McLean

Born 1944, Glasgow
Lives and works in London
Studied 1961-63 Glasgow School of Art
1963-66 Studied at St Martin's School of Art
1981 DAAD Fellowship, Berlin
1985 John Moores 1st Painting Prize.

Selected Exhibitions [*denotes solo exhibition]
1965 Five Young Artists, Institute of Contemporary Art, London;
1966 Painting and Sculpture Today, Grabowski Gallery, London; Young Britain,
Altman & Co, New York

1969 Konrad Fischer, Dusseldorf*; Op Losse Schroeven, Stedelijk Museum,
Amsterdam; When Attitudes Become Form, Kunsthalle, Bern; 557,087, Seattle Art
Museum, Seattle
1970 King for a Day, Nova Scotia College of Art Gallery, Halifax*; Information,
Museum of Modern Art, Oxford;
Place and Progress, Edmondton Art Gallery, Alberta; Prospect-Projection, Kunsthalle,
Dusseldorf; Road Show, Beinale de Sao Paolo (British Council travelling exhibition),
Sao Paolo
1971 Objects no Concepts, Situation, London*; The British Avant Garde, New York
Cultural Centre, New York; Galerie Yvon Lambert, Paris*
1973 An Element of Landscape, Arts Council of Great Britain travelling exhibition,
New York
1975 Early Works 1967-1975, Museum of Modern Art, Oxford*;
Robert Self Gallery, Newcastle*; Nice Style: The End of an Era 1971-1975, PMJ Self,
London*; Art after Dada, JPL Gallery, London
1976 Group Show, Carlisle City Museum and Art Gallery, Cumbria
1977 New Political Drawings, Robert Self Gallery, London and Newcastle*; In Terms
of, and Institutional Farce Sculpture, Serpentine Gallery, London; Documenta 6,
Kassel;
Observations Observed, Biennale des Jeunes, Paris
1978 The Object of Excercise?, The Kitchen (performance sculpture and drawing
installation with Rosi McLean), New York*; Museum of Drawers, Institute of
Contemporary Arts, London
1979 University Gallery, Southampton*; Barry Barker, London*; InK, Zurich*; An
Uncertain Art Anglais, ARC, Paris;
Un Morceau de Gateaux in Inside Outside, Royal College of Art (with Sylvia Ziranek,
London; Lives, Hayward Gallery, London; Books, Felicity Samuel, London; Performance
Symposium, (CAYA), Centre Georges Pompidou, Paris;
Performance Festival Palazzo Grassi, Venice; It's a Can Opener, Performance Festival,
Vienna; A Certain Smile, InK
1980 New Works and Performance/Actions Positions, Third Eye Centre, Glasgow*;
Dokumentation 7, InK, Zurich; Art in the Seventies, Bienalle, Venice
1981 Chantal Crousel, Paris*; Musee d'Art et d'Industrie, St Etienne*; Art and
Project, Amsterdam*; Kunsthalle, Basel*; Anthony d'Offay Gallery, London*; A New
Spirit in Painting, Royal Academy of Arts, London; New Work, Anthony d'Offay
Gallery, London; The 4th Sydney Biennale, Art Gallery of New South Wales, Sydney;
British Sculpture in the Twentieth Century, Whitechapel Art Gallery, London; 1982
Greta Insam, Vienna*; Kanransha Gallery, Tokyo*;
Mary Boone Gallery, New York*; Modern Art Galerie, Vienna*;
Chantal Crousel, Paris*; Aspects of British Art Today, British Council touring
exhibition, Japan; Documenta 7, Museum Fredericianum, Kassel; Zeitgeist, Martin-
Gropius-Bau, Berlin; Anthony d'Offay Gallery, London
1982/3 Van Abbemuseum, Eindhoven*
1983 Kanransha Gallery, Tokyo*; Kiki Maier-Hahn*;
DAAD Gallery, Berlin*; Dany Keller, Munich*; Whitechapel Art Gallery, London*;
Institute of Contemporary Art, London*; Thought and Action, Laforet Museum, Tokyo;
Art in Aid of Amnesty, Work of Art Gallery, London; New Art, Tate Gallery, London
1984 Galerie Fahnemann, Berlin*; Badischer Kunstverein, Karlsruhe*; Dany Keller,
Munich*; Kanransha Gallery, Tokyo*; Bernard Jacobson Gallery, New York*; When
Attitudes Become Form, Kettle's Yard, Cambridge; The Critical Eye, Yale Centre for
British Art, New Haven, Connecticut; An International Survey of Recent Painting and
Sculpture, Museum of Modern Art, New York; The British Art Show, Arts Council
Touring Exhibition, New York
1985 Anthony d'Offay Gallery, London*; Bernard Jacobson Gallery, London*; Galerie
Gmyrek, Dusseldorf*; Tate Gallery, London*; Bilder fur Frankfurt, Bestandausstellung
des Museums fur Moderne Kunst, Frankfurt/Main; John Moores Liverpool Exhibition
14, Walker Art Gallery, Liverpool;
Towards an Art for Peace Biennale, Rene Block, Hamburg;
Homage aus Gemmes, I.C.C., Berlin; Sculptor's Drawings, Scottish Arts Council,
Edinburgh; 7000 Oaks, Kunsthalle, Tubingen
1985/86 11 European Painters, National Gallery, Athens
1986 Bernard Jacobson Gallery, London*; Anthony d'Offay Gallery, London*; The
Scottish Gallery, Edinburgh*;
Peter Moores Liverpool Project 8: Out of Line, Walker Art Gallery, Liverpool; The
Sydney Biennale, Art Gallery of New South Wales, Sydney
1987 Anthony d'Offay Gallery, London*; Galerie Fahnemann, Berlin*; Hillman
Holland, Atlanta*; British Art in the 20th Century, Royal Academy of Arts, London;
Current Affairs, Museum of Modern Art, Oxford; British Council touring exhibition to
National Gallery, Praque; Vessel, Serpentine Gallery, London; Viewpoint: British Art of
the 1980s, Museum of Modern Art (The British Council), Brussels
1987/88 Bingo, Bingo, Bango, Bongo, Tokyo
1988 Museum von Hadendaagse, Netherlands*; Galerie Gmyrek, Dusseldorf*; Tate
Gallery, London*; British Home Made, Rouen; Out of Clay: Creations in Clay by Artists,
Potters and Sculptors, City Art Gallery, Manchester; Twenty Years of British Sculpture,
Le Harve
1989 Galerie Fahnemann, Berlin*; Scottish Gallery, London*;
Balkon mit Facher, DAAD, Berlin; Scottish Art since 1900, Scottish National Gallery of
Modern Art, Edinburgh
1990 Arnolfini Gallery, Bristol*; Kanransha Gallery, Tokyo*; Glasgow Print Studio,
Glasgow*; Henry Moore Sculpture Studio, Dean Clough, Halifax*; Great British Art
Show, McLennan Gallery; Artists designing for Rambert, Gardner Arts Centre, Brighton
1991 Minimal Moves, Gmyrek Gallerie*; Recent Aquisitions, Mental Monotypes,
William Jackson Gallery, London*; Monotypes on Steel by Bruce McLean, Miriam

Shiell Fine Art, Toronto*; Moving Goal Posts, Berkely Square Gallery, London*; Bruce McLean: Work, Harris Museum and Art Gallery, Preston*; Contemporary Scottish Art, Royal West of England Academy, Bristol
1992 Scottish Gallery, Edinburgh*; Bruce McLean: Keramik, Droysen, Berlin*.

Selected Performances
1965 Mary waving Goodbye to the trains, performance for street and roof, St Martin's School of Art, London
1969 Interview Sculpture with Gilbert and George, St Martins School of Art, Royal College of Art, and Hanover Grand, London
1972 Grab it While You Can in British Thing, (with Nice Style), Sonja Henie Niels Onstad Foundation, Oslo
1973 Semi Domestic Poses, Royal College of Art, London
1974 A Problem of Positioning, (lecture/demonstration with Paul Richards) Architectural Association, London; Final Pose Piece, Morton's Restaurant, London; Nice Syle: End of an Era 1971-1975, Robert Self Gallery, London
1975 Objects no Concept, Museum of Modern Art, Oxford
1978 The Object of Exercise (with Rosie McLean), The Kitchen, New York
1979 The Masterwork, Award Winning Fishknife, (with Paul Richards), Riverside Studios, London
1980 Action at a Distance, Questions of Misinterpretation, FruitMarket Gallery, Edinburgh; A Thinner Brim, Third Eye Centre, Glasgow; Possibly a Nude by a Coal Bunker, Riverside Studios, London; High up on a Baroque Palazzo, The Mickery Theatre, Amsterdam
1981 A Contemporary Dance, Kunsthalle, Basel
1982 Farewell performance, Riverside Studios, London; Painting on the Angst, Anthony d'Offay Gallery, London
1983 Yet Another bad Turn-up, Riverside Studios, London
1985 Simple Manners and Physical Violence, Tate Gallery, London
1986 A Song for the North, Tate Gallery, Liverpool
1988 The Invention of Tradition, Tate Gallery, Liverpool; A Ball is not a Dancing School, Whitechapel Art Gallery, London
1990 Vertical Balcony, Arnolfini, Bristol; Dean Clough, Halifax: Tramway, Glasgow.

Selected Films
1970 The Elusive Sculptor, Richard Long, 10min, b/w, Video
1971 A Million Smiles for One of Your Miles, Walter, 15min, b/w, sound, 16mm
1973 The Masterwork, 120min, b/w, sound, 16mm.

Theatre and Stage Design
1989 Soldat, Rambert Dance Company, London
1992 The Empres of Newfoundland, After Image for Channel Four Television.

Collections
Arts Council of Great Britain
British Council
Contemporary Arts Society
Glasgow Museums and Art Galleries
Het Kruithaus Kunstmuseum, Den Bosch
National Museum of Modern Art, Osaka, Japan
Saatchi Collection, London
South Bank Centee, London
Tate Gallery, London
Tochigi Prefecul Museum of Fine Art, Japan
University of Southampton
Van Abbenmuseum, Eindhoven
Victoria and Albert Museum, London
Harris Museum and Art gallery, Preston
Aberdeen Art Gallery
Royal Museum of Scotland, Edinburgh
National Gallery of Modern Art, Edinburgh.

Selected Bibliography
C. Harrison, 'Some Recent Sculpture in Britain', Studio International, vol.177, no.907, 1969
R. Cork, 'Humour as the Weapon to Demolish the Establishment', Evening Standard, 5 Nov, 1971
C. Tisdall, 'King for a Day', Guardian, 11 March 1972
L. Lippard, Dematerialisation of the Art Object, Studio Vista, New York, 1973
M. Hartney, 'Nice Style at Garage', Studio International, vol. 188, no. 971 1974
P. Overy, 'Irony at Oxford', The Times, 13 May 19975
W. Furlong, Interview with Bruce Mclean, catalogue for Hayward Annual, Arts Council of Great Britain, London
N. Dimitrijevic, Bruce McLean Un Certain Art Anglais, Musee d'Art Moderne de la Ville de Paris
S. Kent, 'The Biography Drawer', Bruce McLean, Third Eye Centre, Glasgow, 1980
D. Brown, 'Bruce Mclean – Oh Really – The Appearance of Non-Prodigal Son or Can You Hear Me at the Front?', Bruce McLean, Third Eye centre, Glasgow, 1980
N. Dimitrijevic, 'There's a Sculpture on My Shoulder and Nice Style: The World's First Pose Band and Performance', Installation, Paintings, Bruce Mclean, Kunsthalle basel, Germany, Whitechapel Art Gallery, London and Stedelijk van Abbemusem, Eindhoven
A New Spirit in Painting (catalogue), Royal Academy of Arts, London, 1981
Documenta 7, (catalogue), Kassel, 1982

Zeitgeist, (catalogue), Berlin, 1982
D. Buwalda, J. James, M. Francis (Ed), Bruce McLean: Berlin/London, Whitechapel Art Gallery, London and DAAD Galerie, Berlin, 1983
N. Rosenthal, Simple Manners or Physical Violence, Galerie Gmyrek, Dusseldorf, Germany, 1983
D. Sudjic, 'The Arnolfini Grows Up', Blueprint, Feb 1988
M. Gooding, Bruce McLean, Phaidon Press, 1990.

Carol McNicoll

Born 1943, Birmingham, England
Lives and works in London.
Studied, 1967-70, Leeds Polytechnic
1970-73 Royal College of Art, London, (MA Ceramics)
1970 Princess of Wales Scholarship (RCA)
Lecturing posts at Camberwell School of Art and Design, London
1988 National University, University of the Andes and Cooperates, Bogota, Columbia, series of lectures and workshops
1990 Banff Centre, Lecturer, Form and Function workshop.

Selected Exhibitions [*denotes solo exhibition]
1974 Royal College of Art Gallery, London, China my China*
1975 Thumb Gallery, London
1976 AXIS Gallery, Paris*
1980 Francis Kyle Gallery, London*
1981 British Ceramics and Textiles, Knokke Heist, Belgium,
1982 The Maker's Eye, Crafts Council Gallery, London; Het Kapelhuis Amersfoort, Netherlands
1984 Artist Potters Now, Museum of Oxford, (touring)
1985 Fast Forward, Institute of Contemporary Arts, London; Het Kapelhuis, Amersfoort, Netherlands; British Ceramics, Het Kruithuis, Den Bosch, Netherlands, British Ceramics; Crafts Council Gallery, London, toured to Ulster, Aberystwyth, Gateshead, Cleveland and Birmingham Museums*; A Collection in the Making, Crafts Council Gallery London,
1987 British Crafts, Hamburg Museum, Germany
1988 Het Kapelhuis, Amersfoort, Netherlands; Gallery Kunstformen Jetzt, Salzburg, Austria
1989 Off the Wheel, Whitworth Gallery, Manchester; 5th Bienale de Chateauroux, France; Auxerre, France, L'Europe des Ceramistes, touring to Madrid, Linz, Budapest, Strasbourg and Campagne Ardennes; Crafts Council Shop. Victoria and Albert Museum, London
1990 Oxford Gallery, Oxford*; Lucie Rie Hans Coper and their pupils, Sainsbury Centre for Visual Arts; British Design exhibition, Tokyo touring to Osaka, Sapporo and Hiroshima; British Ceramics in Norway, touring to Bergen, Nordenfjeldske Industrial Arts Museum Trondheim and the Art Museum Oslo
1991 The Abstract Vessel, Oriel Gallery, Cardiff, touring to Aberdeen and Haverford West; Colours of the Earth, British Council Exhibition touring India; Aspects of Sculpture, Galerie Handwerk, Munich; British Ceramics, touring to Santa Fe and New York.

Collections
British Craft Council, London
Victoria and Albert Museum London
Cleveland Craft Centre Gallery, North Yorkshire
Paisley Art Gallery, Scotland
Ulster Museum, Belfast
Knokke Heist Municipality, Belgium
Dordrecht Museum, Holland
National Gallery, Victoria, Australia
Museum Het Princess Hof, Leeuivarden, Holland
Museum Boymans van Beuningen , Rotterdam
Bolton Museum, Lancashire
Birmingham Museum and Art Gallery
Shipley City Art Gallery, Gateshead
Glasgow City Art Gallery
Norwich Castle Museum
Bedfordshire Schools' Art Collection
Contemporary Arts Society, London
British Council, London
Hove Museum.
Design and commissions
1980-84 Rising Hawk Pottery, Stoke-on-Trent
1983 Ware-house Designs, Tokyo
1985-86 Next Interiors, England
1980-present Axis diffusion, Paris
1990 14 Business and the Arts awards commissioned by ABSA for their 1990 ceremony
1992 Glass collection for Victoria Glass, London.

Selected Bibliography
C. Reid, 'A Culture of Doodles', Crafts 64, September/October 1983
'What Next', Crafts 77, November/December 1985
T. Harrod, 'Carol McNicoll Ceramics', International Journal of Ceramics and Glass no

2, February/March 1986
P. Gough, 'Carol McNicoll Ceramics', Crafts 78, January/February 1986
T. Harrod, 'Bridging the Divide', Crafts 80, May/June 1986
'Carol McNicoll Ceramics 1972-85', Gallery News, Aberystwyth Arts Centre, 1986
H. Pim, 'Carol McNicoll Ceramics', Ceramic Review no 97, January/February 1986
P. Wright, 'A View from the South', Craftwork no 11, Spring 1986
E. Lewenstein, 'Carol McNicoll Slip-Caster Extraordinary', Ceramic Review no 117,
May/June 1989
T. Harrod, Crafts 100, September/October 1989
R. Hill, 'Six of the Best', Crafts 106, September/October 1990
O. Watson, R. Deacon, Carol McNicoll Ceramics, Crafts Council, London, 1985
Fast Forward, ICA, London, 1985
T. Harrod, British Ceramic, Museum Het Kruithuis, 's-Hertogenbosh, 1985
Artist Potters Now, Museum of Oxford, 1984
3 English Ceramists, Keramisch Werkcentrum Heusden, Holland, 1982
P. Dormer, The New Ceramics, Thames and Hudson, London, 1982
Great British Design, British Council, London, 1990
J. Houston, The Abstract Vessel : Ceramics in Studio, Bellew Publishing, Oriel/Welsh
Arts Council, 1991
Colours of The Earth, British Council, London, 1991.

Rosa Nguyen

Born 1960, London
Lives and works in London.
Studied 1979-82 Middlesex Polytechnic, BA (Hons)
1983-86 MA, Royal College of Art, London
1989 Received Award from Greater London Art
Teaching 1990 part-time on Foundation Art course, Oxford Polytechnic, BA (Hons)
Middlesex Polytechnic; conducting workshops for Triangle project, Glasgow
1991 Teaching part-time at North Staffordshire Polytechnic, Oxford Polytechnic,
Camberwell School of Art
1992 Artist in residence, Norwood Comprehensive School for Girls, London.

Selected Exhibitions [*denotes solo exhibition]
1988 Locus Gallery, London*; Gallery L, Hamburg; Seibu Department Stores, Tokyo;
Le Cube, Paris; Clayworks, Manchester City Art Gallery; Decorative Arts Award,
Sothebys, London
1989 Jugend Gestaltet, Munich; British Arts, Marianne Heller Gallery, Heidenberg;
Zoo Check, for the Zoo Check Organization, Creaser Gallery, London; Contemporary
Arts Society, London
1990 National Garden Festival, Gateshead; Triangle Project, Glasgow; International
Ceramics, Edinburgh Festival; Manchester Royal Exchange Theatre; Leeds City Art
Gallery; Art for Cambodia, London
1991 Contemporary Applied Arts, London*; Horses, New Academy Galleries, London;
Noah's Ark, The Minories Gallery, Colchester
1992 Christie's Contemporary Arts sale; Leicestershire collection for schools and
colleges; East End Open Studios
1993 Ally Eappeline Shop*; Kunst Contemporary Art, Holland.

Commissions
1988-91 For private Collections : portraits of a bull terrier, dachshund and British
bulldog
For corporate collections : painted plates and painted tiles
1990 Tile panels for the Gateshead National Garden Festival Elephant sculptures for
the Triangle project, Glasgow
1991 Collection of painted plates for Wing Wah restaurant, London
1992 Collection of terracotta neckpieces for Ally Cappeline, London Fashion Week
1993 Collection of terracotta neck and waist pieces, Ally Cappeline Winter London
Fashion Week.

Selected Bibliography
A. Suttie, The New Spirit in Craft and Design, Crafts Council, London, 1987
J. Houston, 'Rosa Nguyen', Contemporary Applied Arts, London, 1991
E. Cooper, Arts Review, May/June 1991.

Lawson Oyekan

Born 1961, London
Lives and works in London.
Studied 1985-1989 Central School of Art and Design, London, BA (Hons)
1991 School of Ceramics and Glass, Royal college of Art, London, MA
Darwin Scholar, Royal College of Art, London 1989
Award of Merit, Fletcher Challenge Ceramics Award 1991, Auckland, New Zealand.

Selected Exhibitions
1991 ARAM Design Limited, London; Galerie Kapelhuis, Amersfoort, Holland
1993 Hand Built Ceramics, Rufford Craft Centre, Nottinghamshire; Ceramic
Contemporaries Exhibition At Victoria and Albert Museum.

Trupti Patel

Born 1957
Lives and works in Essex.
Studied 1974-82 M.S. University of Baroda, MA Sculpture
1983-85 Royal College of Art (British Council Scholarship).

Selected Exhibitions
Museum of Mankind, London; Royal College of Art, London; Nigel Greenwood Gallery,
London; Castle Museum, Nottingham; Leicestershire Museum and Art Gallery.

Collections
The British Council, London
Victoria and Albert Museum, London
Royal College of Art, London.

Grayson Perry

Born 1962, Chelmsford
Lives and works in London.
Studied 1978-79 Braintree College of Further Education (film)
1979-82 Portsmouth Polytechnic.

Selected Exhibitions [*denotes solo exhibition]
1982 Young Contemporaries, Institute of Contemporary Arts, London; Neo-Naturists,
B2 Gallery, Wapping
1983 Ian Birkstead Gallery, London
1984 James Birch Gallery, London*
1985 Essex artists, Epping Forest Museum and Minories, Colchester; Curious Christian
Art, James Birch Gallery, London; Gallozi e la Placa, New York; James Birch Gallery*
1986 International Contemporary Arts Fair, Olympia; Mandelzoon, Rome; Minories,
Colchester
1987 Birch and Conran, London*
1988 Read Stremmel Gallery, San Antonio, Texas; Los Angeles Art Fair; Birch and
Conran, London*
1989 Nishi Azabu Wall, Tokyo*
1990 Words and Volume, Garth Clark Gallery, New York; Birch and Conran, London*
1991 Garth Clark Gallery, New York*
1992 Fine Cannibals, Oldham, Stockport and Warrington; David Gill Gallery, London.

Jacqueline Poncelet

Born 1947, Liege, Belgium
Lives and works in London.
Studied 1969-72 Royal College of Art, London
1965-69 Wolverhampton College of Art
1978-79 British Council Bicentennial Arts Fellowship USA.

Selected Exhibitions [*denotes solo exhibition]
1972 International Ceramics, Victoria and Albert Museum
1973 Glenys Barton and Jacqueline Poncelet, British Crafts Centre, London;
Craftsman's Art, Crafts Advisory committee at Victoria and Albert Museum
1974 2nd Chunichi International Exhibition of Ceramic Art, Nagoya, Japan; Everyman
a Patron, Crafts Advisory Committee Gallery; Outside Tradition, Ulster Museum; 32
degrees, Concorso Internationale, Faenza, Italy
1976 Six Studio Potters, Victoria and Albert Museum
1977 British Potters 77, Graham Gallery, New York; Jacqueline Poncelet Ceramics,
British Crafts Centre, London*
1978 Alison Britton and Jacqueline Poncelet, Galerie het Kapelhuis, Amersfoort,
Holland; British Ceramics, Gementelijk Museum, Princesshof, Holland
1979 Jacqueline Poncelet Ceramics, Hadler Rodriguez Gallery, New York*
1980 Alison Britton and Jacqueline Poncelet, Galerie Het Kapelhuis and Kruithuis
Museum, Den Bosch, Holland
1981 Jacqueline Poncelet, New Ceramics, Crafts Council Gallery, London*; British
ceramics and Textiles, Scharpoord. Knokke Heist, Belgium
1982 Gallery L, Hamburg
1984 Miharudo Gallery, Tokyo; Britska Keramika, Czechoslovakia
1985 British Ceramics, Dienst Beeldende Kunst, Holland; Fast Forward, Institute of
Contemporary Art, London
1986 Max Protetch Gallery, New York; Whitechapel Art Gallery, London; Bing J
Grondahl, Copenhagen; Aperto, Venice Biennale, Italy
1987 Riverside Studios London*; Kettle's Yard, Cambridge
1988 The Third Eye, Glasgow
1990 Contemporary British Crafts, Japan
1991 The Abstract Vessel, Oriel Gallery, Cardiff
1992 Colours of the Earth, British Council Exhibition touring India; Somatic States,
Middlesex University and Norwich Gallery; Artist's Choice, Angela Flowers.

Collections
Birmingham City Museum and Art Gallery
Chunichi Collection of Ceramics, Japan

Crafts Council, London
Museum Boymans van Beuningen, Rotterdam
Museum of Modern Art, New York
National Gallery of Victoria, Australia
National Museum, Stockholm
Royal Scottish Museum, Edinburgh
Stedelijk Museum, Amsterdam
Vestlandstre Kunstenindustrimuseum, Bergen
Victoria and Albert Museum, London
Museum fur Kunst und Gewerbe, Hamburg
Arts Council Collection, London.

Selected Bibliography
R. Deacon, Jacqueline Poncelet : New Ceramics, Crafts Council, London, 1981
Fast Forward, I.C.A, London, 1985
D.Ward, Jacqui Poncelet, Riverside Studios, London, 1987
Colours of The Earth, British Council, London, 1991.

Sara Radstone

Born 1955, London
Lives and works in London.
Studied 1975-76 Hertfordshire College of Art and Design
1976-79 Camberwell School of Arts and Crafts
Awarded 1981 Sainsbury Trust award
1988 Unilever Prize at the Portobello Contemporary Art Festival
1991 Greater London Arts Award
1992 Oppenheim-John Downes Memorial Trust Award
Teaching 1982-1990 West Surrey College of Art and Design, Farnham
1990 University of Colorado, Boulder, USA
1984-present Wimbledon School of Art, London
1992-present Camberwell College of Art, London
Visiting Lecturer 1990 at University of Seoul, Museum of Contemporary Art, Seoul
1991 Harbourfront Arts Centre, Toronto, Ontario
New York State College of Ceramics, Alfred University, USA.

Selected Exhibitions [*denotes solo exhibition]
1983 Crafts Council Shop, Victoria and Albert Museum, London*
1984 Galerie Charlotte Hennig, Darmstadt
1986 Anatol Orient, London*
1988 Anatol Orient, London*
1989 5th Biennale of Ceramics, Musee Bertrand, Chateauroux
1990 Sara Radstone and Angus Suttie, Contemporary Applied Arts, London; Gallery Miharudo, Tokyo
1991 Galerie L, Hamburg; British Ceramics Now, Bellas Artes, New York City and Santa Fe.

Collections
Crafts Council, London
Victoria and Albert Museum, London
British Council, London
Robert and Lisa Sainsbury Collection, University of East Anglia
Paisley Museum and Art Gallery
Ulster Museum, Belfast
Buckinghamshire County Museum
Cleveland County Museum Services
Contemporary Art Society, London
Swindon Museum
Town of Chateauroux, France
Frankfurt Museum.

Selected Bibliography
G. Gilroy, review of Jugend Gestaltet, Crafts 51, London, July/August 1991
R. Deacon, 'Fragile Presences', Crafts 62, London, May/June 1983
B. Blandino, Coiled Pottery, A & C Black, 1984
Ceramics Monthly, January 1984 (USA)
M. Lamarova, 'British Ceramics in Czechoslovakia', American Craft, February/March 1985
A. Britton, review of exhibition at Anatol Orient, Crafts 82, September/October 1986
Angus Suttie, 'Sara Radstone', Ceramic Review no 100, July/August 1986
E. Cooper, review of Potted History at the Gardner centre, Crafts 84, January/February 1987
G. Hughes, review of Six Ways, Arts Review, February 1988
A. Britton, review of Six Ways, Crafts 92, May/June 1988
P.Rice and C. Gowring, British Studio Ceramics in the 20th Century, Barrie and Jenkins, London, 1989
J. Hamlyn, review of Keramik aus England, Crafts 97, March/April 1989
O. Watson, British Studio Pottery : The Victoria and Albert Museum Collection, Phaidon/Christies, London, 1990
A. Britton, 'Sara Radstone and Angus Suttie', Contemporary Applied Arts, London, 1990
J. Norrie, review of Sara Radstone and Angus Suttie at Contemporary Applied Arts, Arts Review no 9, February 1990
T. Harrod, review of Sara Radstone and Angus Suttie at Contemporary Applied Arts, Crafts 104, May/June 1990
G. Clark, The Potter's Art, Abbeville, 1992.

Sarah Scampton

Born 1961
Lives and Works in London.
Studied 1979-80 Foundation Course, Bath Academy of Art, Corsham, Wiltshire
1981-84 Camberwell School of Art, BA Hons
Awarded 1991 McColl Arts Foundation Bursary.

Selected Exhibitions [*denotes solo exhibition]
1985 New Ceramics, Winchester Gallery, touring to Summer Show, British Craft Centre London; The Christmas Show, British Craft Centre, London
1986 The Christmas Show, Contemporary Applied Arts, London
1987 39th International Handwerks Messe, Jugend Gestaltet, Munich (Prizewinner)
1988 Showcase, Institute of Contemporary Arts, London; New Faces, Crafts Council Shop, Victoria and Albert Museum
1989 Clay Bodies, Contemporary Applied Arts, London
1990 Showcase exhibition, Crafts Council shop, Victoria and Albert Museum*; Andrew Usiskin Contemporary Art Gallery, Flask Walk, London*; Contemporary British Crafts, Miharudo Gallery, Takashimaya Department store, Japan
1991 British Ceramics, Bellas Artes Gallery, New York and Santa Fe.

Collections
Shigaraki Ceramic Cultural Park, Tokyo.

Selected Bibliography
E. Lewenstein, 'Sarah Scampton', Ceramic Review, May/June 1990.

Richard Slee

Born 1946, Carlisle, Cumbria
Lives and works in Brighton.
Studied 1964-65 Carlisle College of Art and Design
1965-70 Central School of Art and Design
1986-88 Royal College of Art
Teaching 1975-1990 Part time at Central Saint Martin's College of Art and Design; Senior Lecturer, Harrow College of Higher Education
1990 Senior Lecturer, Camberwell College of Arts
1992 Professor of the London Institute.

Selected Exhibitions [*denotes solo exhibition]
1977 Smith and Others Gallery, Kensington Church Walk*
1981 British Ceramics and Textiles, Knokke Heist, Belgium (British Council)
1982 Nonconformists ?, Galerie Het Kapelhuis, Amersfoort, Netherlands
1983 Victoria and Albert Museum, Crafts Council Shop*; Fifty Five Pots, The Orchard Gallery, Londonderry
1984 British Crafts Centre
1985 British Ceramics, Museum Het Kruithuit, Holland; Fast Forward, Institute of Contemporary Arts, London and Kettle's Yard, Cambridge
1986 Britain in Vienna, Kuenstlerhuis, Vienna, Austria; Victoria and Albert Museum, Crafts Council Shop, London*
1987 Ceramisti Inglesi a Bassano, Bassano del Grappa, Italy; Our Domestic Landscape, Corner House Gallery, Manchester and UK tour; Hordaland Kunstnersentrum, Bergen and Gallery F15. Oslo, Norway*
1988 National Museum of Modern Art, Kyoto and Tokyo; Contemporary British Crafts, British Council; Crafts Council, London, Gallery RA, Gallery De Witte; New Art Objects from Britain and Holland, Amsterdam
1989 Gallerie Het Kapelhuis, Holland
1990 National Museum, Stockholm, Sweden*; Three Ways of Seeing, Crafts Council, London and UK tour, retrospective; British Design, British Council, Tokyo; Navy Pier, Chicago Arts Fair
1991 Arte Fiera '91, Bologna, Italy; Aberystwyth Arts Centre, University College of Wales*; Contemporary Work in Ceramic, Brighton Polytechnic Gallery
1992 Aspects of Sculpture, Marianne Heller Gallery, Sandhausen, Germany (touring) ; Exhibition of the 3rd International Clay Arts Camp in Korea, Seoul
1993 Anticipation, Stedelijk Museum, Amsterdam; Visions of Craft 1972-1993, Crafts Council, London.

Collections
Bradford City Museum
Buckinghamshire County Museum
Crafts Council, London
Cleveland Crafts Centre
Hove Museum
James Mayor Gallery, London
Knokke Heist Municipality, Belgium
Leicester City Museum
Los Angeles County Museum

Museum Het Kruithuis, Holland
Museum of Modern Art, Kyoto
National Museum, Stockholm
Norwich City Art Gallery
Paisley Museum
Stedelijk Museum, Amsterdam
University College of Wales
Victoria and Albert Museum, London.

Selected Bibliography
J. Street Porter, 'Slee Notes', Design, May 1973
R. Slee, 'Richard Slee', Ceramic Review, January/February 1983
P. Dormer, 'Routes of Exchange', Crafts, May/June 1984
E. Allington, 'Richard Slee', in British ceramics (cat.) Museum Het Kruithuis, Holland, 1985
A. Britton, 'Five Pots on the Horizon', in Our Domestic Landscape (cat), Corner House, Manchester, 1986
J. Houston, Richard Slee : Ceramics in studio, Bellew, London, 1990
J. Berry, 'Richard Slee', Ceramic Review, September/October 1990
P. Greenhalgh, 'Profile : Richard Slee', Studio Pottery, February 1993.

Martin Smith

Born 1950, Braintree, Essex
Lives and works in London.
Studied 1970-1 Ipswich School of Art
1971-4 Bristol Polytechnic, Faculty of Art and Design, Dip AD
1975-77 Royal College of Art, MA (RCA)
Teaching 1977-83 Loughborough College of Art and Design
1979-80 Camberwell School of Art and Crafts
1980-83 Brighton Polytechnic
1983-85 Loughborough College of Art and Design, Senior Lecturer, Ceramics
1986-89 Camberwell School of Art and Crafts, Senior Lecturer, Ceramics
1989- Royal College of Art, Senior Tutor, Ceramics.

Selected Exhibitions [*denotes solo exhibition]
1975 New Faces, British Crafts Centre, London
1978 Atmosphere, London*; Five British Ceramists, Het Princesshof, Leeuwarden; Keramic-Unikate aus England, Rosenthal Studio Haus, Hamburg
1979 Galerie de Witte Voet, Amsterdam*
1980 Jugend Gestaltet, Exempla 80, Munich and Vienna
1981 British Ceramics and Textiles, Knokke-Heist, Belgium
1981-2 Forms around a vessel : ceramics by Martin Smith, Lotherton Hall, Leeds, touring*; Victoria and Albert craft shop, London*
1982 The Maker's Eye, Crafts Council, London
1983 Fifty Five Pots, Orchard Gallery, Londonderry; Modern British Studio Ceramics, Queensbury/Hunt Studio, London
1984 Garth Clark Gallery, London and Los Angeles*; Artist Potters Now, Museum of Oxford and tour; British Ceramics for Czechoslovakia, touring Bratislava, Prague and Brno
1985 Garth Clark Gallery, New York*; British Crafts Centre London*; British Ceramics, Museum Het Kruithuis, Den Bosch; Craft Matters, John Hansard Gallery, Southampton; Rituals of Tea, Garth Clark Gallery, New York, Los Angeles
1986 Galerie de Witte Voet, Amsterdam*; International Contemporary Ceramics Salon, Garth Clark Gallery at Smiths Gallery, London; Potted History, Gardner Centre Gallery, University of Sussex, Brighton; Made in Britain (Neue Tendenzen der Englischen Keramik); Galerie Kunsthandwerk, Berlin, touring
1987 Garth Clark Gallery, New York*
1988 Kunstformen Jetzt!, Salzburg*; Diversions on a theme, Contemporary Applied Arts, London*; Six Ways, Anatol Orient, London; London Amsterdam, New Art Objects from Britain and Holland, Crafts Council London and Gallerie Ra and Galerie de Witte Voet, Amsterdam; Contemporary British Crafts, Kyoto, Tokyo; Special Exhibition of Top Ceramic Designers, the 2nd International Ceramics Competition '89 Mino, Japan
1989 Galerie Kapelhuis, Amersfoort, Netherlands*
1990 Galerie de Witte Voet, Amsterdam, Netherlands*
1991 Fourteen British Potters, Galleria Il Giardino Dell'Arte, Bologna, Italy; British Ceramics, Bellas Artes, Santa Fe, New York
1992 Contemporary Applied Arts, London.*

Collections
Leeds Art Galleries (Lotherton Hall)
Crafts Council, London
Victoria and Albert Museum, London
Museum Boymans van Beuningen, Rotterdam
Museum Het Princesshof, Leeuwarden
Bolton Museum and Art Gallery
Leicester Museum
Wiltshire Museum
Cleveland County Council
Shipley Gallery, Tyne and Wear
Museum Het Kruithuis, Den Bosch

Stedelijk Museum Amsterdam
Los Angeles County Museum of Art
National Museum of Modern Art, Kyoto
National Museum of Modern Art, Tokyo
Scottish Museum, Edinburgh.

Selected Bibliography
M. Drexler Lynn, Clay Today, Los Angeles County Museum of Art, Chronicle Books, 1990
M. Margetts, International Crafts, Thames & Hudson, 1991
A. Britton, Contemporary Applied Arts, 1992.

Angus Suttie

Born 1946, Tealing, Scotland
Died 16 June 1993.
Studied 1976-79 Camberwell School of Arts and Crafts, London
Teaching 1980 onwards Morley College, London
1986 onwards Camberwell School of Arts and Crafts, London
1986 and 1991 Guest lecturer, West Surrey College of Art and Design, Farnham.

Selected Exhibitions [*denotes solo exhibition]
1982 Opening Exhibition, Aspects Gallery, London; Clay in the garden, Seven Dials Gallery, London
1983 Plates, Sculptures, Teapots and Cups, Victoria and Albert Museum Craft Shop, London*; Fifty Five Pots, The Orchard Gallery, Londonderry
1984 Cross Currents, The Power House Museum, Sydney; British Ceramics, Bratislava, Prague and Brno, Czechoslovakia
1985 The Whole Works, Anatol Orient Gallery, London*; British Ceramics, Den Bosch, Netherlands
1986 British Ceramics, Dorothy Weiss Gallery, San Francisco
1987 Jugs, Crafts Council shop, Victoria and Albert Museum, London*; Cloth, Clay and Wood, British Council Exhibition touring South America and Malaysia
1988 London/Amsterdam : New Art Objects, Crafts Council Gallery, London, Galerie de Witte Voet and Galerie Ra, Amsterdam; British Crafts, Tokyo and Kyoto, Japan
1990 Sara Radstone and Angus Suttie, Contemporary Applied Arts, London
1991 Cosmos Tea Bowls, Gallery Tom, Tokyo; Colours of the Earth, British Council Exhibition touring India ; Metamorphosis of Contemporary Ceramics, Shigaraki, Japan.

Collections
Crafts Council, London
Ulster Museum
Hertford County Collection
Australia Crafts Board, Sydney
Den Bosch Museum, Netherlands
Victoria and Albert Museum, London
University College Wales, Aberystwyth
Bolton Museum and Art Gallery
Paisley Museum and Art Gallery
Bedford County Council
Museum Boymans van Beuningen, Rotterdam
National Museum of Modern Art, Kyoto, Japan
Public Collection, Royston, Hertfordshire
Essex County Council Collection
Cleveland Craft Centre, Middlesborough
The British Council Collection
Museum of Contemporary Ceramic Art, Shigaraki, Japan.

Selected Bibliography
E. Cooper, 'Teasing the Imagination', Ceramic Review No 94, July/August 1985
S. Radstone and A. Orient, The Whole Works, Anatol Orient Gallery, London, 1986
P. Dormer, 'Structural Logic', Crafts 88, September/October 1987
A. Britton, 'Sara Radstone and Angus Suttie', Contemporary Applied Arts, London, 1990
T. Harrod, 'Sara Radstone and Angus Suttie', Crafts 104, May/June 1990.

list of works

For reasons of space a few works may not be exhibited at certain venues

Paul Astbury

Raincoat
clay, raincoat, plastic
1992
8 x 152 x 152 cm

Tree in a Landscape
clay, tree, timber base
1993
456 x 152 x 152 cm

Chair 1
clay, wooden chair and plastic
1984
86 x 81 x 51 cm

Chair 2
1984
clay, wooden chair and plastic
91 x 51 x 61 cm

Gordon Baldwin

White Vessel
1991
fired clay
49 x 51 cm

Tilt
1993
fired clay
62 x 51 x x 11 cm

Cygnus
1993
fired clay
75 x 29 x 29 cm

Zoomorphic
1991
fired clay
30 x 46 x 26 cm

Vessel with Painting
1990-1991
fired clay
49 x 42 x 12 cm

Conical Vessel
1991
fired clay
75 x 37 x 20 cm

Stephenie Bergman

Forty Plates
1990-1992
30 x 30 cm each

Alison Britton

Pink Pot
1993
earthenware
47 x 44 x 21 cm

White Pot with Stalk
1993
earthenware
41 x 29 x 18 cm

Dark Blue Pleated Pot
1993
earthenware
38.5 x 31 x 29.5 cm

Tony Cragg

Laib
1990
earthenware
67 x 50 x 53 cm
collection Museum Het Kruithuis, 's-
Hertogenbosch, The Netherlands, gift
from and work made at the European
Ceramics Work Centre

In Camera
1993
earthenware
77 x 49 x 59 cm
collection Museum Het Kruithuis, 's-
Hertogenbosch, The Netherlands, gift
from and work made at the European
Ceramics Work Centre

Jill Crowley

Pink Hand
1993
stoneware
34 x 36 cm

Blue Hand
1993
stoneware
26 x 37 x 40 cm

Turquoise Arm
1992
stoneware
7 x 60 x 23 cm

Blue Arm
1993
stoneware
15 x 70 x 18 cm

Three Feet
1992
stoneware
11 x 16 x 8 cm
15 x 23 x 9 cm
1993
15 x 13 x 21 cm

Karen Densham

Model of a Horse
earthenware
1992
48 cm

Yellow Archeress
1992
earthenware
29 x 39 cm

Pipe
1991
earthenware
48 cm

Rug
1991
earthenware
48 cm

Close to Reality
1993
earthenware
46 cm

Hunter
1992
earthenware
36 x 44 cm

Ruth Dupré

Twelve Shoes
1991-1993
stoneware
approx life size

White Night
1993
stoneware
41 x 30 x 23 cm

Tlelatopec, Arise
1993
stoneware
42 x 30 x 24 cm

Ken Eastman

Pot
1993
stoneware
25 cm

Bulge
1993
stoneware
48 x 35 x 18 cm

Swell Pot
1993
stoneware
45 x 39 x 12 cm

Form and Content
(pair)
1993
stoneware
33 x 23 x 22. cm each

Philip Eglin

Madonna col Bambino
1991
earthenware
100 cm

Les Deux Femmes
1989
earthenware
71 cm
private collection

Dejeunner sur l'Herbe
(after Manet)
1990
earthenware

Reclining Nude
1991
earthenware
28cm

Female Nude with Pot
1992
earthenware
36.5 x 18 x 13.5 cm

Elizabeth Fritsch

Pots about Equilibrium
a group of nine pieces
1992-3
stoneware
from 24 – 48.5 cm

Antony Gormley

Twenty Four Hours
1988
terracotta
9m (2 – 30 cm high)

Susan Halls

Monkeys and Apes
(group of twenty)
1992
paper-clay, mixed media, Raku
10 cm

Gazelle
1993
paper-clay, Raku
46 x 29 x 45 cm approx

Giraffe
1993
paper-clay, Raku
90 x 37 x 33 cm

Zebra
1993
paper-clay, mixed media, Raku
52 x 48 x 40 cm

Gwyn Hanssen Pigott

Still Life
(four piece)
1992
porcelain
25cm

Still Life
(seven piece)
porcelain
26.5 x 27 x 18 cm

Ewen Henderson

Two Megaliths
1993
bone china, porcelain, laminated onto
stoneware
110 cm

Jar
1990
bone china, porcelain, laminated onto
stoneware

Upright Jar
1993
bone china, porcelain, laminated onto
stoneware
50 x 27 x 18 cm

Tracey Heyes

Grecian.
1993
stoneware
52 x 23 cm

Untitled
1993
stoneware

Untitled
1992
stoneware

Untitled
1992
stoneware

Jefford Horrigan

Fella
1990
clay, fabric and colour laser print
175 x 64 x 47 cm

Mass
1989
clay, fabric and laser print
46 x 68 x 31 cm

Dome
1983
clay, fabric and newspaper
33 x 26 x 13 cm

North
1993
clay, fabric and colour laser print
125 x 73 x 18 cm

Edge
1992
clay, fabric and colour laser print
211 x 13 x 23 cm

Bryan Illsley

Man with a Pigtail
1989
earthenware
160 cm

Spike
1993
earthenware
120 x 33 x 47 cm

Plant
1993
earthenware
35 x 27 x 16 cm

Piperack
1993
earthenware
28 x 30 x 15 cm

Vegetables
1993
earthenware
48 x 12 x 10 cm
29 x 11 x 11 cm
41 x 11 x 11 cm

Pamela Leung

The Wall
1990
180 x 120 x 30 cm

Wedding scene
1992-93
152 x 137 x 76 cm

Gillian Lowndes

Hook Figure
1991
loofahs, slip
135cm

Hook Figure
1991
loofahs, slip
168 cm

Hook Figure
1993
loofahs, slip
147 cm

Hook Figure
1993
loofahs, slip
56 x 51 cm

Bruce McLean

Jug
1986
53 x 41 x 6 cm
collection Wakefield Museum,
Art Gallery and Castles

Jug
1988
50 x 73 x 12 cm
collection Museum Het Kruithuis,
's-Hertogenbosch, Netherlands

Carol McNicoll

Ladakh Tulip Pot
1993
earthenware
25 cm

Small Tulip Pot
1993
earthenware
37 x 40 x 38 cm

Water Tulip Pot
1993
earthenware
46 x 38 x 40 cm

Rosa Nguyen

Sacred Cow Head
1993
25 cm

Sacred Cow Head
1993
25 cm

Sacred Cow Head (Oval)
1993
47 x 55 x 5 cm

Orangutan
1993
crank and terracotta

Lawson Oyekan

Wrapped Pot
1992
terracotta
series of five
80 x 20 cm
90 x 40 cm
82.5 x 36 x 36 cm
91 x 35 x 35 cm
90 x 52 x 52 cm

Manifestation of Dance
1992
porcelain
28 x 56 cm

Passage Pot
1992
stoneware
18 x 46 cm

Trupti Patel

Journey Column iv
1992
earttenware
205 x 40 cm

Sycamore Seeds
1993
earthenware
210 x 44 x 46 cm

Five Stories
1993
earthenware

Grayson Perry

Childhood Trauma Manifesting
Itself in Later Life
1992
34 x 33 cm

PR
1992
28 x 30 cm

Applied Art
1991

Grayson Perry Trophy Awarded
to a Person with Good Taste
1992
46.5 x 28 cm

Jacqueline Poncelet

Object 'Against the Wall'
1985
105 x 40 x 35 cm

Object in Four Parts
1986
76 x 28 x 29 cm
79 x 42 x 15 cm
61 x 37 x 10 cm
61 x 37 x 10 cm

The Handbag
1986
87 x 40 x 17 cm

Object in Three Parts
1986
96 x 80 x 40 cm

Sara Radstone

Untitled
(group of four)
1993
stoneware
124 - 132 cm

Untitled
1992
stoneware
64 x 48 cm

Sarah Scampton

Mother and Child
1993
87 x 90 cm approx

Untitled
1993
80 x 50 x 31 cm

Untitled
1993
73 x 27 x 37 cm

Richard Slee

Toby Jug
1992
45 cm approx

Punch
1991
69.5 x 32 x 52 cm

Stump
1990
40 x 12 x 17 cm

Thorn
1990
45 x 20 x 13 cm

Tankard
1990
30 x 25 x 26 cm

Leaf
1990
57 x 23 diam cm

Sprout
1990
50 x 20 diam cm

Jug
1990
26 x13 21 cm

Pigs Head
1993
8 x 38 x 25 cm

Martin Smith

Substance and Shadow No. VI
1993
Raku
40 cm

Fact and Expectation No. 111
1992
Brick Clay, Copper leaf
14.5 x 47 x 29 cm

Fact and Expectation No. 1V
1993
Raku
7.5 x 46 x 36 cm

Fact and Expectation No. V.
1993
eartheware, copper leaf
7.5 x 45 x 37 cm

Angus Suttie

Pot
1989
earthenware
39 cm
collection Crafts Council

Doodle Plate
1982
earthenware
15 x 62 cm
collection Crafts Council

Pot
1989
earthenware
38.5 x 35 x 18.5 cm
collection Essex County Council

Pot
1989
earthenware
42 x 40 x 20 cm approx
The Eagle Collection